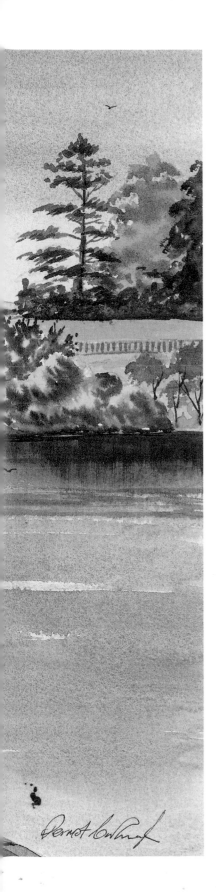

Dermot Cavanagh

with Howard Elson

BBC

Acknowledgements

I would like to express my sincere thanks to Brian McKibben, without whose faith *Awash with Colour* would have been only an idea I had had; my wife Maria for her support, patience and understanding throughout the years of obsession with painting; Howard Elson, my agent, for transferring my original manuscript into legible text; all the viewers of *Awash with Colour* around the world; and finally to my mum and dad for buying me a box of watercolour paints when I was seven.

Pages 2–3: *Dungannon Park Lake, County Tyrone*

This book is published to accompany the television series entitled *Awash with Colour*, which was first broadcast in 1997. The series was produced by Straight Forward Productions Limited for BBC Television.

Series Producer: John Nicholson
Executive Producer: Ian Kennedy
Producer: Jane Kelly

Published by BBC Worldwide Limited, Woodlands, 80 Wood Lane, London W12 0TT

First published 2000 Reprinted 2001
This paperback edition first published 2002.
Text copyright © Dermot Cavanagh and Howard Elson 2000
Artwork copyright © Dermot Cavanagh 1999
The moral right of the authors has been asserted.

Photographs: Ashley Morrison, copyright © BBC Worldwide 2000

ISBN 0 563 55158 5 (hardback edition)
ISBN 0 563 48805 0 (paperback edition)

Commissioning Editor: Vivien Bowler
Project Editor: Khadija Manjlai
Copy-editor: Emma Callery
Art Director: Linda Blakemore
Designer: Janet James

Set in Bembo and Gill

Printed and bound in France by Pollina, n° L88349
Colour separations by Radstock Reproductions Ltd, Midsomer Norton
Jacket and case printed by Lawrence Allen Ltd, Weston-super-Mare

Awash with Colour

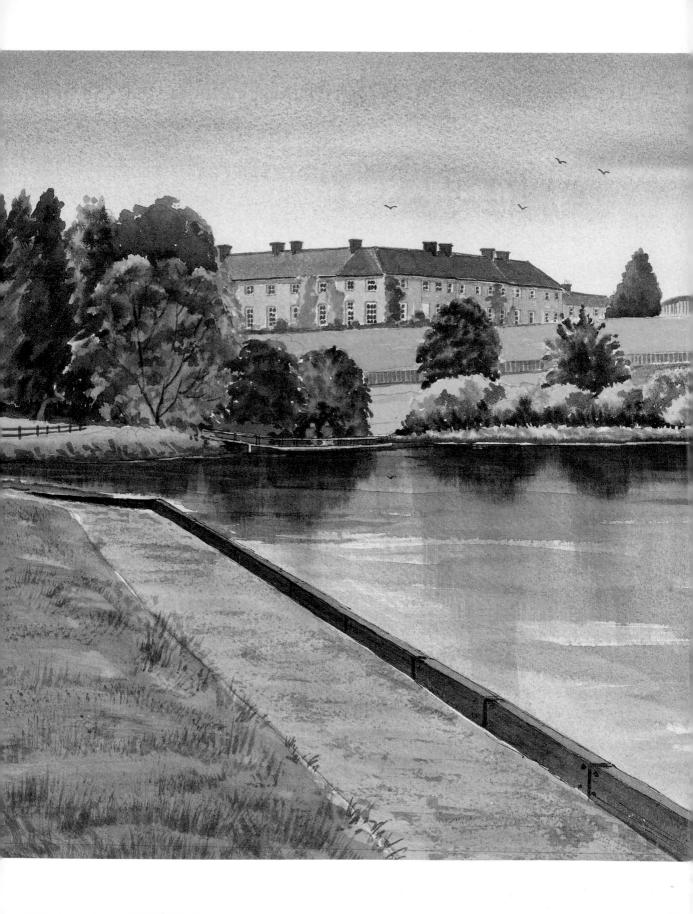

CONTENTS

A Brush with Dermot Cavanagh

Funny how things turn out for the best. Maybe if I hadn't been ill with asthma and bronchitis as a young lad, I might never have taken up painting.

I was seven years old and confined to my bed for long periods of time in an effort to cure me of my illness. To relieve me of my boredom, my mother bought me a box of watercolour paints. I spent the next few weeks of my self-imposed quarantine attempting to paint everything I could see from my bedroom window. It was here that a love of landscape painting was born. Shortly after taking up my new-found vocation, the sickness that had plagued me for so long disappeared, leaving only a great hunger to paint.

I lived in a farming area in the heart of rural Ireland, so I had plenty of subjects for my paintings. As I progressed, learning new things every time I picked up my brush, I started to observe the landscape and how light played a part in the make-up of every painting.

Whenever I saw a fabulous scene created by the light and atmosphere, it seemed simplicity itself to paint. Yet it proved so hard to find the right techniques to capture it on paper. Problems, though, only helped to spur me on.

With no one to show me first-hand, I started to study prints of old masters on the tea trays, biscuit tins and place mats we had at home. I tried to figure out exactly what techniques these great artists might have used. John Constable was my favourite: his paintings were everywhere.

Ever-improving materials

By my early teens I was still painting with poor-quality materials. For thicker texture I used poster paint, unaware that there was such a thing as oil paint. My eyes were opened one afternoon while I was waiting for a bus to take me home from the town of Dungannon. A sign in a chemist's shop window read: Artists' Materials For Sale Upstairs. It was the discovery of a lifetime.

Upstairs I found brushes of all shapes and sizes, tubes of paint in what seemed like a million different colours, canvas, easels, oils. It was a veritable treasure trove – an oasis in my desert of frustration. It became a favourite haunt. All the money I earned from weekend and holiday jobs was spent in this shop on the materials I needed.

In my quest for knowledge to become a better painter, I also visited the local library, searching for art books. I had a voracious appetite to learn, and at secondary school, art was my favourite subject almost to the detriment of all others. Yet at 16 I felt I needed to get a regular job like everyone else and became an apprentice electrician. Painting was relegated to my spare time, yet still I felt the desire to learn more.

Ever-improving techniques

To improve my skills and find some direction I enrolled in a local art class. Within a few minutes of starting to paint at that first session I was advised by the tutor that I was wasting my time and money. There was very little she could teach me that I didn't know already. She was a great encouragement to me and I suppose this was the real beginning to my painting career.

My work as an electrician took me to Belfast. It was during my stay there that I started to visit art galleries. For the first time, I saw real paintings instead of having to make do with pictures in books. I could feel the texture, smell the paint and marvel at the brush work. Seeing art in the raw first-hand encouraged me to try different mediums. I took up acrylics and then developed an interest in chalk pastels. I also discovered a number of English watercolour artists, including Ray Campbell Smith, James Fletcher Watson and Roland Hilder. They all inspired me.

I collected brushes and experimented with paper textures and types. Gradually, I realized I needed fewer and fewer colours to make up the shades I wanted or to create the effects I aspired to. I also discovered I needed a minimum of brushes to help me to paint. One brush could do a number of exercises. Why use more? I began to like the results I was getting.

Becoming a teacher

My job as an electrician took me all over Ireland. Travelling around such stunning countryside, I saw subjects for paintings everywhere I went. I had recently married my wife, Maria, and converted the spare bedroom of our house into an art studio, where I spent most of my free time painting from the sketches I had made earlier or from photographs. I held local exhibitions and even started to sell the odd painting. It wasn't long before I became known in the neighbourhood as Dermot Cavanagh, the artist.

In 1991 I was asked by the vice-principal of the local technical college if I would take evening classes

there and teach people to paint. At first I was reluctant to get involved because I had very little experience, but it proved to be a major turning point in my life and career. It was here I discovered that I had a knack and enthusiasm for teaching. I tried to make each session as enjoyable as possible, determined to solve all the problems I had experienced as an aspiring painter myself. It was a hands-on approach to teaching and it worked well.

Within two years I started to run weekend painting courses from home. I provided the tuition and Maria provided the refreshments. But things soon got out of hand. The courses were so much in demand that we needed more space or a new home! I contacted the administrator of the Argory National Trust property near Moy, who allowed me to set up another studio and expand the teaching courses further. This developed into leisure painting holidays in Ireland, Spain and Cyprus.

Through the holiday scheme, I became involved with the Northern Ireland Tourist Board (NITB) and we worked closely together exploiting the full potential of Northern Ireland as a tourist attraction. I was invited along to their fairs, exhibitions and shows to put on my own painting demonstrations and talk about the potential of this beautiful country – a painter's paradise.

I was undertaking an even bigger workload now, with seminars, workshops, demonstrations, holidays, work studies and courses, as well as trying to hold down a full-time job as an electrician. I soon exhausted all my annual leave and days off to fulfil my extra curriculum.

Moving towards television

Throughout all these activities I was regularly being told that my style of teaching seemed ideal for television and that I should think seriously about launching my own series which, of course, was easier said than done. I had come a long way since starting out on my art adventure, reaching goals and achieving ambitions through sheer enthusiasm, perseverance and hard work. I was a painter, and a part-timer at that. I knew nothing of television.

But one evening, with the words of encouragement ringing in my ears, I sat down in the kitchen and devised a concept for a television programme on teaching art. It was a simple format based on my own hands-on style of tuition: a young, enthusiastic artist travelling the towns and countryside of Ireland in search of a subject for painting. I had very little hope of ever getting the idea off the ground. But it's funny how things turn out.

It was through my association with the Northern Ireland Tourist Board that in the autumn of 1994 I was put in touch with an independent television production company called Straight Forward and told them of my idea. They warmed to the proposal and asked me to arrange a meeting with one of their directors, a former BBC producer called John Nicholson, to see if the idea could be developed into a fully fledged series. But Nicholson proved to be a very elusive person to track down, even though he lived just a few miles from me. It was only after several months of following abortive leads with other television companies that John and I finally crossed paths.

Things then started to happen quickly. We expanded the idea and presented a concept to BBC TV Northern Ireland. They liked what they saw and commissioned a series of ten shows to be called *Awash with Colour*. The first programme went into production in March 1997, featuring the delightful Suzanne Dando. Surprisingly, I was totally relaxed and at ease in front of the camera. I must have used up my full quota of nervous energy trying to turn this dream of mine into reality.

Since then, *Awash with Colour* has captured the imagination of the public not only in the United Kingdom, but in many places throughout the world. The show has developed considerably from the original format I put together on my kitchen table. In the first three series we filmed fifty programmes and featured myriad guest celebrities, including Gloria Hunniford, Charlie Dimmock, Pat Bonner, Mary Black, Jan Leeming, Gerry Anderson, Brian Kennedy, Loyd Grossman and many more.

We have visited some fantastic places throughout Ireland and it has been a great privilege to bring the wonder and the beauty of its landscape into people's living rooms. As well as helping experienced artists to improve their painting and explore new techniques, I sincerely hope that we have encouraged others to set out on this big painting adventure.

I have always prided myself that I can teach anyone to paint. If they have the desire to paint and the will to learn, I have the ability to teach them. That is the essence of *Awash with Colour*.

It is incredible to think what can be achieved with enthusiasm, perseverance and hard work. But then I never go anywhere without them.

CHAPTER 1

Starting to paint

When I wrote this book, my daughter, Gemma, was almost two years old. Maybe we should have asked her the question 'Why paint?' because she seemed to be at her happiest sitting on the floor of the kitchen with a sheet of paper in front of her surrounded by coloured pencils, pens and crayons.

I have often wondered what the result would be if a two-year-old child were left alone in a room with a bucket of paint and a 3in brush. Perhaps we all know the answer to that one already.

A few years ago I was commissioned to paint a life-sized picture of Jesus by a local parish priest. It was an oil painting on a large canvas measuring 120 x 240cm (4 x 8ft), which was destined to be hung at the back of the church facing the altar. I worked on the painting every day for two weeks leading up to Easter Sunday. It was to be dedicated during Devotions on the evening of that special day of celebrations.

The canvas was far too big to get into my upstairs studio, so I worked on the project in the kitchen. I had to stand on a chair to paint in the face and upper part of the canvas. I found the painting of the hands and the feet the most difficult to achieve but I managed to complete my task on the night before the big day and I was delighted with the result.

As it was extremely late when I finished my epic, I decided to leave the clearing-up until the next morning. I left the palette and brushes on a chair beside the painting and went to bed exhausted from my efforts.

My second daughter, Laura, who was three at the time, got up earlier than usual on that Easter Sunday morning and went downstairs to play.

When I eventually walked in the kitchen and found her, Laura beamed at me. She was wearing such a smile on her face which radiated pride at what she had done. Then I saw the reason for her contentment. There were red, yellow and blue swirls all over Our Lord's feet and ankles. Bright, vivid colours. I just stared at the painting, dumbstruck. When I finally overcame my shock, panic took hold and I set about repairing the damage like a man possessed. Thankfully, oil paint in a wet state is easily removed, and the picture was in the church later that afternoon and on schedule.

Making an impression

I firmly believe that the earliest human instinct is to make a mark, to express oneself. We all want to feel good, and painting certainly does that. It is a natural instinct, like walking, and is, I believe, the second most important form of expression next to talking. Children love painting because they do not fear it. Similarly, in prehistoric times Stone-age man found expression through painting on cave walls.

There are many theories as to why primitive man painted on the walls of his cave. I believe it gave him a special feeling of satisfaction. It was an instinctive action and it was fun. It was good to look at and brightened up the cave. Like all of us, he painted what he saw all around him, nothing more. We've been doing the same thing ever since. Stone-age man was certainly not intelligent enough to realize that he was recording history for future generations to discover. He had no thoughts of posterity and no desire to produce what could be termed the first visual diary. But like children today, he had no fear of painting – after all, there was no one to tell him that what he was doing was wrong and that he had no talent.

Nowadays, the difference between professional artists, who make their living from their work, and those who take up painting as a hobby, for relaxation, or as a retirement occupation, is that professionals are children who have never stopped playing with paint. I readily admit to being one myself.

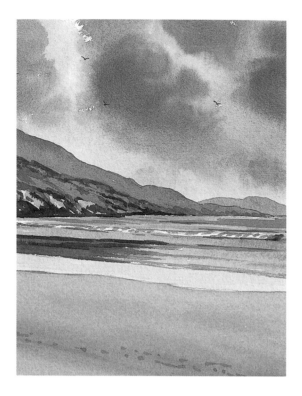

Capturing the moment

Throughout our lives we experience many situations that stir our imagination. They might include a beautiful sunset by the sea, a moonlit autumn night, a balmy summer's afternoon in the countryside, a crisp and frosty morning in the snow, or a bustling marketplace in the centre of a city. Things like these make me feel good. If I could only package them and take them home, I know I would feel good forever!

Alas, the situations that convey these feelings are changeable. Yet, if we are able to paint them while the memory and images are fresh in our minds, we can capture them forever and retain that wonderful feeling. Every time you look at a painting you have created yourself it brings back memories. That is the great joy that painting can give you. It's a precious talent, and the remarkable thing is that we all have the ability to paint if we possess the desire.

Believe in yourself

When I was about 13 years old I came across a beautiful book by the French author Antoine de Saint-Exupéry. It was called *The Little Prince* and it inspired me greatly.

The child in the book makes a drawing of a boa constrictor swallowing an elephant and shows it to adults, who all think it looks like a hat. Disheartened, he gives up drawing entirely. Yet, unlike the character in the book, it inspired me to keep on painting despite all the criticism, the problems and pitfalls I experienced. I determined I would never succumb to outside pressure from grown-ups or anyone else, and continued to paint, regardless of what people thought about my pictures. I have never regretted it.

Over the years I have read numerous books on a variety of subjects, I have listened to all kinds of music, and I've come to the conclusion that we are all artists in our own way. Writers paint with words and composers paint with music as an artist might paint with colour. We are all trying to convey the same thing. Atmosphere. Drama. Fervour and life.

So why paint?

Long before the invention of the camera, people painted to record life and recreate scenes they had witnessed or experienced for posterity. Yet these were only minor reasons. There were far more people painting for pleasure and their own enjoyment than simply for keeping a record. Painting has always been a popular pastime and now even more so than ever before.

Taste in painting, like beauty, is a subjective matter. What one person adores another will detest – that's how it should be. When we paint, we should try to produce an impression of what we see and how we feel, not just a photographic copy that's flat and without life. It is an emotional experience. Indeed, when we paint a scene we should leave out far more than we put in. In other words, we must be selective in our composition, highlighting and intensifying the things that really strike us and fire our imagination.

Whenever I tell people to look at a scene with half-closed eyes, I do so because it obliterates all the irrelevant details that clutter

up the picture. We should always aspire to capture the scene as we see it. It is a personal interpretation. Five artists can paint the same landscape – and each piece of work will be different. That is what is so exciting about painting.

Personal interpretation is what made the glorious French Impressionists so fantastic. They really opened a lot of people's eyes and sent art hurtling off in a totally different direction. Their paintings stood out. Light was diffused, giving no real sense of detail, yet there was massive impact from the colours, the shadows, reflections, the sheer beauty of the portrayal. The Impressionists stimulated the mind and, quite rightly: they are as popular today as they have ever been.

Most of us want to look at nice things and warm colours and that is the quintessence of what the Impressionists gave us. And it is really what most people want to paint themselves – a representation of what they are looking at.

As a young boy I used to look out of my window and try to recapture what I could see. But I really wanted to reproduce only the good bits, the warm colours. I left all the bad bits and the messy parts behind. I'm still doing it today. When I'm out for a walk on an autumn day and I see the clouds brushing across the sky in a warm glow, or the dark shades of thunder-bearing clouds creeping across the heavens, when I see the setting sun shining on the church, making it stand out like a beacon as the light dances on the side of the spire and the gable end wall…it all makes me want to paint.

Why paint?

As you might have guessed by now, there are many answers to the question, 'why paint?', yet one thing remains true to all of them: when you get bitten by the painting bug, you never want to stop.

I do hope some of my passion for painting will rub off when you read this book. I will take you on a great adventure and point you in the right direction. I will guide you through the wonders of painting and hand over my tips and

advice and pass on a few tricks of the trade I have picked up over the years. I hope I will be able to solve some of the painting problems that might have reared their ugly heads from time to time in your own painting. I am confident you will emerge from the experience a better painter. I can guarantee we will have some fun together along the way. At the end of it all I hope you will have found out for yourself… why paint?

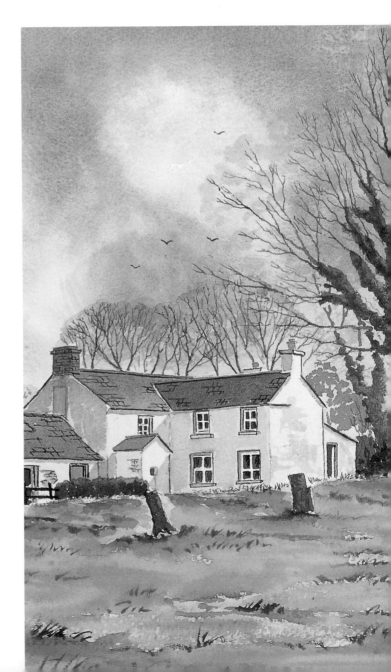

CHAPTER 2

Choosing materials

I use a small range of equipment, which I have put together over the years and which works very well for me. I would recommend that you get together the same basic materials so that whenever you attempt the exercises featured in this book, you will be able to get similar results.

Remember: if you look after your equipment and do not mistreat it, it won't let you down.

Let's start with brushes.

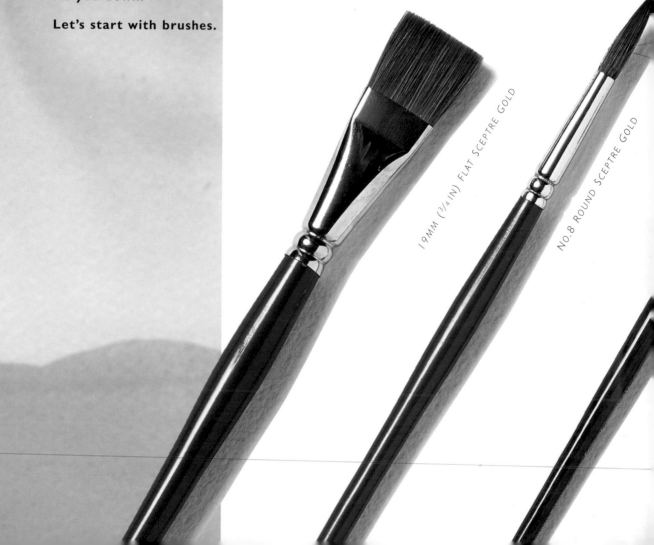

19MM (3/4 IN) FLAT SCEPTRE GOLD

NO.8 ROUND SCEPTRE GOLD

BRUSHES

Brushes are made in many styles, shapes and sizes, all varying in price. Remember that you do not have to purchase the most expensive range to get the best results. I only ever use four:

The 19mm (¾ in) Flat Sceptre Gold, I feel, is a vital piece of equipment for all watercolour painters. It is a fairly large brush containing an equal blend of sable and synthetic (nylon) hair. Sable gives the brush greater water retention; nylon gives it spring. I use this brush a lot for quickly painting broad areas, such as skies and foregrounds. After the initial sketch is completed, use this brush to paint most of the picture, filling in the broad areas to begin with.

The No.8 Round Sceptre Gold comes to a fine point and I use this for some detail work within the painting. It is ideal for broad and medium washes and retains a lot of water. Used on its side, it is a perfect brush for painting trees, shrubs and foliage. It is also good for blocking in walls, the roofs of houses and the panes of glass within the windows. It is a perfect tool for feeding detail into the foreground.

The No.5 Cirrus Sable has a fine point and, like the No.8 Round Sceptre Gold, is perfect for the more intricate work within a painting. Held on its side, it is good for detailing small trees and shrubs, twigs and branches, gateposts and fences. It is also very useful for small areas such as window panes and for putting fine detail into the foreground.

The No.2 Cirrus Rigger is a longer-haired brush than the average and comes to a very fine point. (It gets its name from when it was used to paint the rigging in pictures of sailing ships.) Use this brush for even more intricate detail – tiny branches, fenceposts, gates, ridge tiles and suchlike. Used on its side, it gives a scumbling effect, which is explored in greater depth in Chapter Four. It can be used like a pen and is very effective.

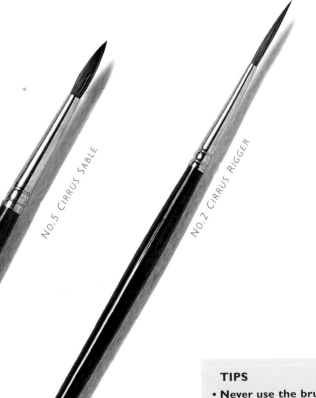

NO.5 CIRRUS SABLE

NO.2 CIRRUS RIGGER

TIPS
- **Never use the brushes you paint with for cleaning up your palette. Mishandled, they will soon deteriorate.**
- **For cleaning up get yourself a big, floppy mop brush with fine, soft hair. It is perfect for the job of cleaning palettes.**

PAPER

Watercolour paper comes in a variety of sizes, weights and textures. Just like brushes, each different type can do a specific job for the artist. Mostly, I use a French paper made from 100% cotton rag. The two that I particularly like are 640gsm (300lb) rough and cold-pressed paper.

The weight of paper is expressed in grams per square metre (pounds per ream). There are three main weights used for watercolour painting: 190gsm (90lb), 300gsm (140lb) and 640gsm (300lb). The heavier the paper, the thicker the sheet; 640gsm (300lb) paper is very thick and I find it adds quality to a painting.

For my own paintings, I prefer the 300gsm (140lb) and 640gsm (300lb) papers. I find the 190gsm (90lb) tends to cockle when wet, so I stay clear of it. My preferred weight also depends on which size sheet I am using. If painting on half-imperial (559 x 381mm/ 22 x 15in) I go for 640gsm (300lb). If I'm working on a quarter-imperial size sheets (381 x 280mm/15 x 11in), I much prefer a 300gsm (140lb) weight.

The surface of the paper differs as well. Smooth-surfaced paper is known as hot-pressed paper. Medium-grain-surfaced paper is known as cold-pressed paper or 'not'. Then there is a rough-surfaced paper known simply as 'rough'. This has a grained surface, which can give some tremendous effects, and I find it works well for landscapes. My own liking is for rough paper, although I am very happy painting on cold-pressed or not surfaces.

All the different kinds of paper are sold in large, separate sheets measuring 762 x 559mm (30 x 22in) which have to be cut to the size you prefer. The sizes are achieved by halving the longest side each time the sheet is cut. You can also pick up a variety of paper weights and qualities in pad or book form.

PAPER AND PAINT

The following are examples of how watercolour washes work on various kinds of paper surfaces.

● Three washes have been applied with a No. 8 brush to cartridge sketching paper. The paint tends to run on this smooth-surfaced paper, although occasionally you can come up with some great effects. It is perfect for sketching but not an ideal surface for watercolour painting.

● The same washes have been applied to 300gsm (140lb) hot-pressed Lana paper. This is a very smooth-surfaced paper with very little texture, similar to cartridge paper. The washes appear flat on the paper and have little depth to them.

• This is the king of all papers as far as I am concerned – a 640gsm (300lb) watercolour paper with a rough surface (tooth). I would use this paper for most of my paintings as it is coarse and chunky. Where the washes have been put down on the paper, you can see that granulation(when the colour separates) has taken place. Because the paper has a certain tooth to it, the paint is dragged from the brush in an irregular manner. This is what gives a coarse edge to trees and a natural roughness to landscapes.

• A totally different effect is achieved when the identical washes are applied to this cold-pressed (or not) paper which is 300gsm (140lb) in weight. On this medium-grain surface there is a certain amount of granulation taking place in the washes: some of the pigment within the wash has fallen into the tiny divots that make up the surface of this paper. There is also a certain amount of roughness around the edge of each wash as it is laid down. This occurs when the brush is dragged across the surface of the paper and the tiny bumps of the texture take some of the wash from the hairs of the brush, leaving other areas of the paper free of paint.

Sketch pads and sketch books

I use an assortment of pads for drawing or making a painting sketch.

A pad of heavy-gauge medium-surface cartridge paper (220gsm/100lb) is a favourite of mine. It comes in A4 size (7¼ x 10¾ in) and I find that the paper's slightly rough surface allows me to sketch on it with paints as well as to draw on it with pencils. It's ideal for making quick sketches.

When sketching with my 2B to 6B pencils, which need a smoother surface, I tend to use A4 cartridge paper sketch pads. These contain 50 sheets of varying weights from 130gsm (60lb) to 220gsm (100lb) in a spiral binding. I also use a 190gsm (90lb) watercolour paper pad. Although I find it useless for painting on, it is very good indeed for pencil drawing and watercolour sketches. Most watercolour pads and blocks contain 20 or more sheets measuring 175 x 125mm (7 x 5in) for the smallest size to 510 x 405mm (20 x 16in) for the largest.

TIP
• I believe one should sketch as much as possible. Carry a sketch pad with you at all times and take every opportunity to draw. It is only by doing this that your sketching skill will improve. Remember that practice makes perfect. The basis of all good painting is understanding the art of drawing.

PAINT

Watercolour paint comes in student and artist quality and is sold in two forms: pans and tubes. Pans are small blocks of paint that have to be softened with water for use. Paint in tubes is much easier to use and can be squeezed directly onto a palette in as small an amount as you need. Tube paint is also easier to break down' and mix and inexpensive to buy.

I have experimented with colour mixes over the years and discovered that with a palette of just nine colours I can create any colour I need. Having a fewer number of core colours is also less confusing and will help you to understand the range of mixes you can obtain.

The colours I use are of artist quality and come from the Winsor and Newton range. They are:

- Winsor Yellow
- Raw Sienna
- Light Red
- French Ultramarine
- Cerulean Blue
- Winsor Blue (Red shade)
- Burnt Sienna
- Neutral Tint
- Alizarin Crimson

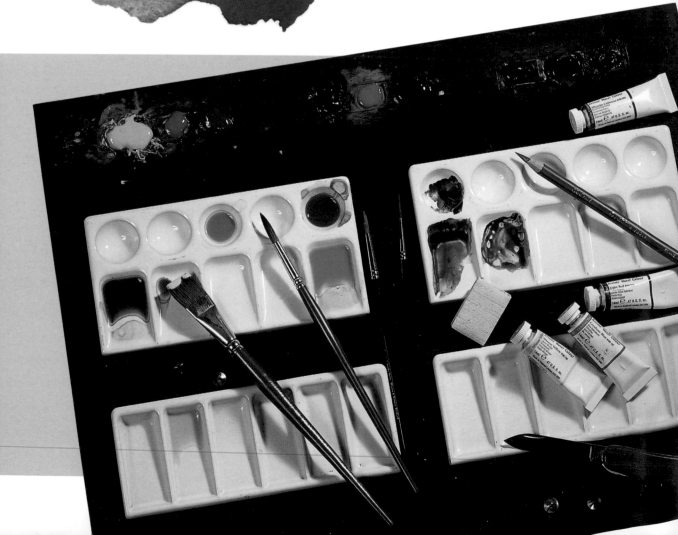

WINSOR YELLOW

RAW SIENNA

LIGHT RED

FRENCH ULTRAMARINE

CERULEAN BLUE

*WINSOR BLUE
(RED SHADE)*

BURNT SIENNA

NEUTRAL TINT

ALIZARIN CRIMSON

TIP
- **Whenever you are laying out paint on your palette, put each colour in the same position every time so that you create a routine and know exactly where each colour is at all times. Can you imagine learning to type if someone changed the position of the keys every time you used the keyboard?**

THE PAINTBOX

I am very proud of my paintbox, but I'm sorry to say that you cannot buy a similar version in the shops.

I designed it and had it made for me a few years ago when I simply couldn't find anything that would hold all the materials I need to take with me. If you are handy, I'm sure you could design and make your own paintbox quite easily.

My paintbox is built of mahogany, which makes it quite heavy to carry, and it has a lockable lid. The inside of the lid houses a drawing board that slides out for use, and behind this I can stash my sketch pads and paper. A wooden tray (see left) sits on top of the open box, and it has four mixing areas, two slant well tiles (the round ones) and two slant tiles made from porcelain, which give me an large amount of space for mixing paints.

Rebated into the wood above the tiles are nine full pans into which I squeeze fresh tube colour before I start to paint.

Beneath this tray is an area housing my nine paints in 14ml (0.47 US floz) tubes, plus space for all my other materials to be neatly stowed away.

I also have a small, black enamel sketchbox, which fits the palm of my hand. It's perfect for making quick sketches in the field.

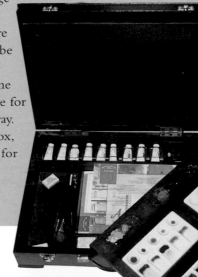

OTHER MATERIALS

Water containers

The most essential item you need for watercolour painting is water. And you need a large container to keep it in.

Using a large water container, such as a bucket, has several advantages:

- If you are using a lot of water, it stays cleaner longer, which means you do not have to change it so often.
- The paint sediment falls to the bottom, so when you clean your brush against the side, you will always be using relatively clean water. This ensures that the colours you then use will be fresh and transparent. There is nothing worse than painting with muddy water.
- A bucket can be hung on to the easel, which means it is readily accessible during painting.

Easel and drawing board

Whenever I am painting in the field, on location, or at home in my studio, I use a steel-framed easel. Choose whatever suits you best.

The particular model I use has adjustable legs to give a great variation in height, and no feet, which makes the easel stand level and stable. The top of the easel can be tilted flat – the ideal position for painting skies. The easel can be adjusted to adapt to any situation and is light and easy to carry.

My drawing board is a piece of plywood, cut to a size to suit me. Measuring 455 x 610mm (18 x 24in), it is big enough to take both half-imperial and quarter-imperial sizes of paper. It is light, easily transported and does not warp when it is wet. The paper is attached to the board with several drawing pins or strips of masking tape.

Pencils

I have a selection of pencils that I use for sketching and painting. I always sketch on watercolour paper with a hard lead pencil, such as an HB. But my paintbox also contains pencils ranging from 2B through to 6B.

The reason I recommend HB pencils for sketching on watercolour paper has to do with the surface of the paper. If the surface is textured, the graphite from a soft pencil such as 2B will smudge the surface of the paper no matter how careful you are. The harder the lead you use on rough paper, the better.

I use soft-leaded pencils (2B to 6B) only when I am drawing on cartridge paper during initial sketches on location. I find the softer lead works well on this type of paper and can give great differences in tone. Leaning heavily on a soft-lead pencil can give dark shading lines. A 2B is ideal for drawing in the initial lines of a sketch. It's a nice, soft pencil that floats easily over the surface of the paper.

Erasers

I always recommend a kneadable putty rubber, which is soft and pliable and can be kneaded by hand. A putty rubber is perfect for cleaning graphite smudges from the paper without damaging the surface texture, which is something other erasers tend to do. It is also very easy to clean after use.

Pens

The drawing pen I use has an 0.5 fibre tip and comes with black, permanent ink which is waterproof. It's light, fast and easy to use. It is a very useful tool for drawing in and strengthening the outlines of buildings when the painting is finished, for emphasizing dark lines, and ideal for signing your name on the completed work.

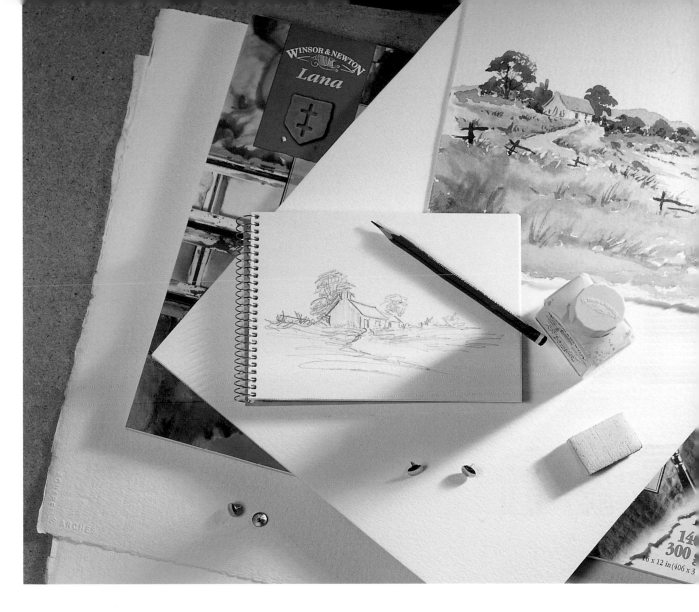

Masking fluid

I find masking fluid (liquid latex) a useful piece of kit, particularly when I need to retain the white of the paper for highlights within the painting. It can also be used for keeping paint clear of window frames, but don't overuse it.

Penknife

I use a penknife for scratching back on paper and removing wet paint from the paper surface, to create special effects. For example, when I am painting a distant bank of trees and I need to insert sunlit branches in the distance, I use the penknife to remove the paint by 'pushing' away the open blade against the paper.

TIPS
- **Try not to apply masking fluid with a good brush because it is difficult to clean off thoroughly after use. Eventually the latex fuses the brush hairs and it becomes useless.**
- **A bottle of masking fluid goes a long way because it should always be used sparingly for highlights and for small white objects.**
- **A penknife is also very useful for sharpening pencils.**

Working with colour

COLOUR MIXING

Regular viewers of *Awash with Colour* will be well aware that I use just nine colours. However, even with such a limited palette, there is a whole wealth of colour I can create through mixing.

KEY
Winsor Yellow **WY**
Raw Sienna **RS**
Light Red **LR**
French Ultramarine **FU**
Cerulean Blue **CB**
Winsor Blue **WB**
(*red shade, rather than green shade*)
Burnt Sienna **BS**
Neutral Tint **NT**
Alizarin Crimson **AC**

Winsor Yellow **WY**

Raw Sienna **RS**

Light Red **LR**

Burnt Sienna **BS**

French Ultramarine **FU**

Neutral Tint **NT**

Alizarin Crimson **AC**

Here are 20 exercises that will show you exactly what can be achieved using my nine colours. With a little practice, you will soon get the hang of it.

1 Winsor Yellow and Winsor Blue

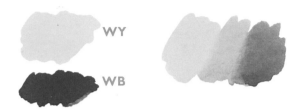

- Put the WY into the mix first (this is very important). Add a tiny amount of WB – perhaps in the ratio of one-fortieth blue to one part yellow to start with – and your first mix will give a light, vibrant green. Use this colour in the foreground areas of paintings to show a sunlit underpaint (for first wash).
- To obtain the second combination (a mid-tone green) increase the strength of the WB. Feed this colour into your foreground areas and it gives a lovely contrast against the lighter green.
- Add more WB to the WY to increase the darkness and lushness of the green. From these two colours alone, an extensive range of greens can be produced. Simply increase the amount of WB in the mixture to achieve a new shade.

2 Winsor Yellow, Winsor Blue and Light Red

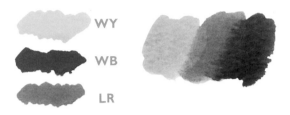

- Introduce LR into the original mixture of WY and WB and immediately you can see it has made a wonderful earthy green, ideal for landscapes.
- Add extra WB and LR to the mixture to create an earthy mid-tone green, which is great for painting trees. The lighter shade we created first I often use for sunlit areas, the darker colour for semi-sunlit regions. It makes a nice contrast.
- Intensify the WB and LR to produce an even darker shade – a thicker-textured green, perfect for capturing darkness in the density of foliage.

3 Burnt Sienna and Winsor Blue

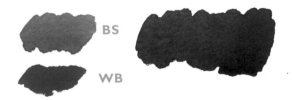

- Start with the BS and add small quantities of WB to gradually darken the colour you create. The first mixture is a deep green, which I find useful for painting conifers and dark foliage where the areas have been untouched by sunlight.
- The second graduation – with the addition of more WB – creates a bluish-green tone. The third combination changes the colour away from green and veers towards the blue side of the spectrum.

Cerulean Blue **CB**

Winsor Blue **WB**
(red shade rather than green)

4 Winsor Yellow and Cerulean Blue

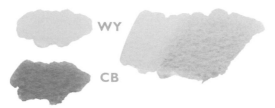

- Add a tiny amount of CB to WY to make a very light, sunlit, frosty green. It is a colour that is found in the landscape on winter mornings, looking out over a sunlit plain. It gives great atmosphere and by increasing the amounts of CB added to the WY you can create cooler shades of this special green. It is excellent for painting foregrounds and foliage.
- Always remember to put the WY into the mix first. It is far easier to mix from light colours to dark. It simply doesn't work in reverse.

5 Winsor Yellow and Neutral Tint

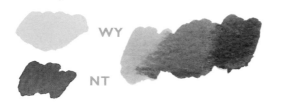

- Introduce a small amount of NT to WY to form a delightful olive green. Add more to make mid-tones and darker tones, which can be used for trees, fields and foliage.

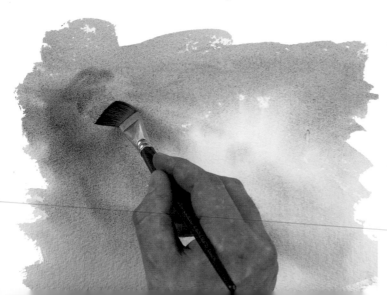

6 French Ultramarine and Light Red

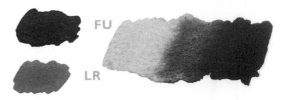

- FU is dominant in this mix, although the mixture needs to be diluted using plenty of water. The initial colour created gives a beautiful sky blue, which can be used for distant hills, trees and mountains. It is also perfect for foreground shadows and landscape toning.
- A touch more FU creates a superb colour for painting clouds. It is also a wonderful colour for shadows particularly those in snow.
- Use further helpings of both colours to create a denser, thicker mixture. This is a shade I use to replicate the shadows on the trunk and branches of trees, and for window panes where the darkness inside can be seen through the glass. You can also use it for casting dark shadows on the underside of slates and for highlighting dark joints, crevices and stones.

7 French Ultramarine and Light Red

- Feed the LR into the mixture first, using plenty of water to dilute the shade you create. Introduce the FU and a series of warm greys emerges, ideal for cloud shadows. This is also a very useful colour for twigs and branches on trees to give a density around the top. It's good, too, for painting slates and roofs, and excellent for shadows on brick and stone.

8 French Ultramarine, Light Red and Alizarin Crimson

- This mixture relies on a large amount of water to produce a colour that is perfect for shadows and has a variety of uses: sunlit tiles and slates, shadows on grass and stone, buildings…It works particularly well if you are painting a white house because it can be used to bathe one side of the building in shadow. Other uses include clouds and snow shadows.
- You can produce a far more purple wash by strengthening the amounts of FU and AC. Use this to colour slates, stones, bricks, distant trees, thunderclouds, water and shadows on water.

9 Cerulean Blue and Neutral Tint

- CB is the dominant colour in this combination. Add quantities of NT as necessary, then mix in large amounts of water to produce a beautiful, shimmering water effect. It works extremely well in snow scenes to form lakes and rivers, and conveys a wonderful feeling of the crystal clear, icy water.
- More NT reduces the amount of water on the brush, and the emerging colour is perfect for soft clouds against an autumn sky.

10 Winsor Blue and Neutral Tint

- Start with WB and mix in small amounts of NT to create a super colour that can replicate sky and water in a harbour. The more water you add to the mixture, the lighter it becomes.
- By increasing the amount of NT, you can mix up a colour that gives an eerie, ominous quality to thunderclouds. Bled into a lighter sky wash, it gives the perfect variation between light and shade.

11 Raw Sienna and Alizarin Crimson

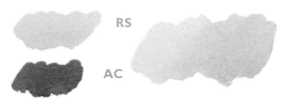

- Add AC to RS and introduce large amounts of water to produce a graduation of shades that can be used for a variety of effects, including pathways, stone buildings, soil and sandy beaches. Diluted further, you can add the colour to clouds and skies to give warmth.
- Darker shades can be created by increasing the amounts of AC in the mix.

TIP
- Always keep a separate piece of the same paper (test paper) you are working on by your side when you are painting, especially when experimenting with colours or applying washes (page 46).

12 Light Red and French Ultramarine

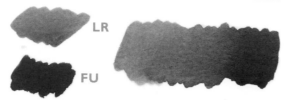

- In some of the previous exercises, FU and LR have been combined to produce many different colours. However, on this occasion, use less water in the initial process to produce a thicker mix. You'll find this is a great colour for stonework.
- You can also graduate the shade with the addition of more FU to provide a very workable colour for painting in shadows on stonework and deep colours within buildings.

13 Burnt Sienna and Neutral Tint

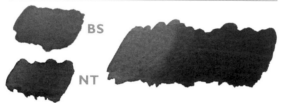

- If you put the BS into this combination first and add small amounts of NT, a deep rich brown is the result. This is ideal for painting trees, stonework, roof tiles, walls, fences, posts and a great variety of other items. Use it when painting ploughed fields to give darker shadows and bring out the definition in furrows and troughs. It is suitable for painting distant fields and far off, tree-covered hills that are slightly brown. The graduations in tone can be used for branches.

14 Raw Sienna and Neutral Tint

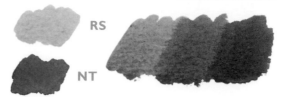

- RS is the dominant colour in this mixture. Add NT in varying degrees to give a very rustic colour, which is perfect for tree foliage in the autumn. Feed the darker progression into foreground colours to create an earthy, rounded texture.

15 Light Red and Alizarin Crimson

- I must admit that this is one of my favourite colour mixes. It produces a lovely rich red for doors, windows and clothing. Anything red in the landscape can be highlighted in this way. Use it, too, for roofing tiles; the graduations in colour can be stunning.

16 Light Red, Raw Sienna and Neutral Tint

- This is a superb colour mix for stonework and sandstone. Add the LR first and then work in small amounts of RS and NT until you achieve the required colour. Lighten by adding water. This is also a useful colour for sandy beaches.
- A handy tip: if you use this for tree trunks, it looks as if the sun is shining on the bark.

17 French Ultramarine, Light Red and Alizarin Crimson

- This mixture is based around FU and a large helping of water. The addition of small quantities of LR and AC softens the blue shade. Then a final extra helping of AC gives the overall colour warmth. Use it for water, skies, shadows on the landscape and shadows on snow.

18 Winsor Yellow, French Ultramarine and Alizarin Crimson

- Add FU to the WY to produce a shade of very pale green. A small amount of AC gives it a freshness and earthiness. If you increase the input of FU and AC, a mid-tone shadowy green emerges. Further additions give a darker green.
- I use these colour tones in various graduations to illustrate the density of foliage on trees and bushes. It's a lovely colour for conifers, where the leaves tend to be a dark blue-green shade.

19 French Ultramarine and Neutral Tint

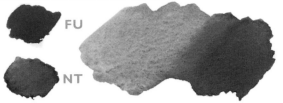

- These two colours combine well for strong skies. Add a healthy portion of NT to FU to give an imposing colour for threatening thunderclouds; small amounts added to the mixture give it a softer appearance.

20 Cerulean Blue and Alizarin Crimson

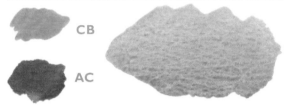

- These two colours are perfect together for creating a sky at sunset with beautiful tones of red shining through a cerulean blue.
- In this particular exercise you will see that granulation is taking place within the colours. Granulation happens when the mixture is applied to a rough paper, which has a textured surface. Some pigments are heavier in weight than others, and once they are mixed together they cause a reaction. Here, the blue separates from the crimson and settles in the tiny crevices on the rough-surfaced paper. It creates a stunning diffused effect for this wonderful mottled paving. Red sky at night...

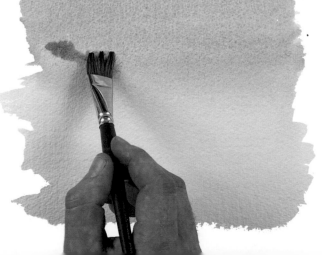

LIGHT

I have always felt more like painting during a day when the sun is shining than at any other time. Maybe this is because of the way a building that looks so drab on a greying overcast morning comes immediately to life when bathed in sunlight, or the way the sun shines on a tree and gives it character and strength… I could go on all day.

I'm not saying it is essential to have a completely blue sky to inspire you to paint. Sunlight that escapes from behind dark stormy clouds can create breathtaking atmosphere as it shines down onto the landscape… like a searchlight bringing out the vibrancy of colours and breathing life into them. The colours look fresher: the greens are more vivid, the shadows more concentrated, giving that perfect contrast between darkness and light.

Sometimes the shadows that are cast by one building on to another, throwing it into partial light, can be especially effective in a painting, giving form and character – and creating drama. Light can do so many things. Here is a series of exercises that shows how light affects painting.

USING LIGHT

- Light is a precious addition to any artist's palette.
- It gives atmosphere and feeling to paintings.
- It can create excitement and conflict, be haunting and mysterious, eerie and magical.
- Light creates space, adds depth and brings vibrancy.
- Light inspires.

Colour mixing

This is a sequence of colour mixes that shows you how to increase the effect of light in a wash.

Twelve different strengths of wash from three mixes are shown here, using just two colours: FU and LR. Adding water to each of the three mixes increases the transparency of the colour and allows the light to radiate through the pigment to reveal the paper beneath. The more the paper can be seen, the lighter the wash appears.

1 Start off with a wash of FU and LR. The FU is the dominant colour in this mixture, therefore the overall shade created is a deep blue. Although very little water is used, the mix remains fluid and free-flowing. It remains dark because less of the white paper is seen through the wash.
2 Water is added to the first mixture to make it more transparent and to allow more of the white paper to be exposed. Use for: blue skies, background hills and trees, shadows on snow scenes and water, and joints in roof tiles and stone.
3 With the addition of extra water, the wash becomes yet lighter. Use for: water, shadows on stonework, pathways through grass.
4 The final wash in this sequence contains the most

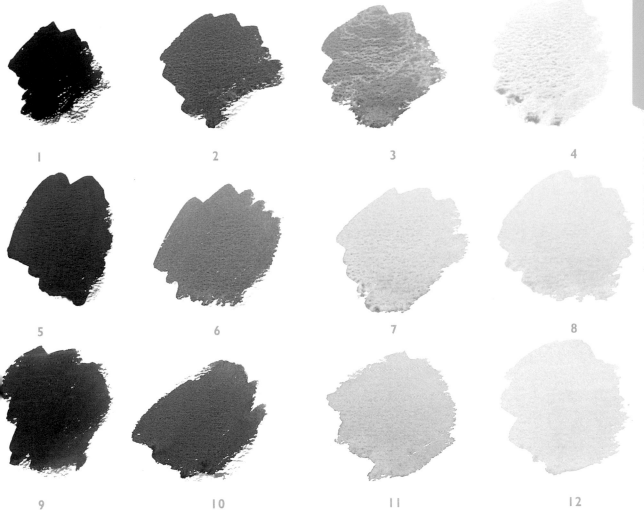

<!-- Swatch labels -->

1 2 3 4

5 6 7 8

9 10 11 12

water and is the lightest of the four colours created as more of the paper's whiteness is allowed to radiate through. Use for: watery blue skies, distant water, shadow on white walls.

5 This wash contains an equal mixture of FU and LR and produces a distinctive shade of brown. Very little water is added to the mixture. Use for: dark warm clouds, branches, trunks, dark foliage, fence posts and so on.

6 As water is introduced to the wash, the overall colour lightens, making it more transparent. Use for: roof tiles in shadow, stonework, branches and winter foliage.

7 The mix becomes lighter still with the addition of more water. Use for: sunlit stone, winter foliage, shadows on snow.

8 The sequence is completed by diluting the mixture even further to reveal a paler, translucent wash. Use for: distant hills, shadows on snow or stone and distant trees.

9 This mix is produced by adding a touch of FU to an LR base with a small amount of water. Use for: woodwork, foliage, roof tiles and warm storm clouds.

10 Extra water makes the mixture lighter. Use for: warm clouds, mountains, roof tiles.

11 The more water that is added to the wash, the paler it becomes. Use for: soft shadows on snow and stonework.

12 This final stage of the sequence shows the wash in its most dilute state. It is the type of mix that can be used to paint sunlit stone and pathways. Use for sunlit clouds, sunlit stonework.

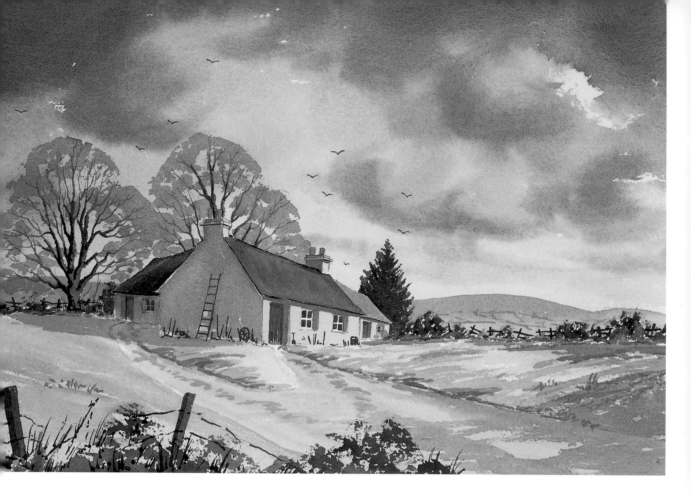

Applying the washes

This is a painting that can be created using the washes illustrated on the previous page made up from just two colours: FU and LR. Experiment with the washes and try to match these as closely as possible to the washes on page 27. Then try the following exercise for yourself.

• After making an initial sketch of the scene, pre-mix all the sky washes. The sky should be completed in about five minutes to avoid hard lines and bleed back occurring. Using the 19mm (¾in) Flat Sceptre Gold brush and a swirling motion to give the cloud effects, start with the lightest mixture of FU and LR to show the recession in the sky and to act as a base for clouds. The sky is receding, and as it falls away into the distance, it gets lighter. Feed in a wash containing more LR than FU to show the warmth in and around the clouds, bleeding it into the sky as it dries.

• Add the wash for the cloud shadows to the underside and left-hand side of the warm clouds. Next add the wash for the blue sky. This is painted along the top of the paper and fed into the wash at the right-hand and left-hand corners. The sky is bluer towards the top. Note the slight shadowy effect on the clouds near the top of the sky, giving a hint of storms.

• Leave the sky to dry completely.

• While this is happening, pre-mix the washes for the foreground. Apply the washes, starting with lightest and work to the darkest, using the 19mm (¾in) brush. Use a very light mix with a little water to fill in the foreground

> **TIP**
> • Keep the entire sky area wet while you are painting it, to allow the washes to blend.

first and then introduce an initial colour for the sunlit snow and to give warmth and glow. The brushstrokes must follow the contour lines of the landscape.

- When the foreground has dried, start work on the trees with the No.5 Cirrus Sable brush. Start with the left-hand tree if you are right-handed and vice versa if you are left-handed. Using a thick, mid-bodied mixture, paint in the trunk of the left-hand tree and the top branches of the trees masked by the cottage, working upwards from the base. Taper off at the top. Use the No.2 Cirrus Rigger for the fine twigs and branches towards the top of the tree.

- Remember that each branch has a dark, shadowed area. When the first wash is almost dry, apply a secondary wash of the same colour to give this effect. This will bleed across and merge with the initial wash because the paper is damp, but it gives that lovely coarse, rounded effect to the trunk and main branches.

- Now you can turn your attention to the cottage. Start with the part of the roof facing the source of light. Use LR with a touch of FU to show the warmth of the sunlight as it hits the tiles. The roof at the back of the house on the outshoot is in shadow because it is facing away from the source of light and has a slightly darker hue. This is formed by adding an equal mix of FU and LR in downward strokes. Apply this wash to selected areas of the sunlit roof to help create texture. Use it sparingly and do not overdo the effect.

- When the roof is dry, apply the washes for the walls. Paint in the shadow on the gable end wall of the cottage and the wall of the outshoot at the back of the building to show that these areas are facing away from the light source. Shadows should be added to both chimneys and under the eaves of the roof at the front.

- Window panes are formed using the No.5 brush and a heavy mix of FU with LR with a little water. The darkness of the mixture will indicate the presence of glass. Exposed white paper provides the frames.

- Return to the trees, the trunks and branches of which should by now be dry, and bring them to life with foliage. Mix the wash for the foliage and apply it very quickly using the side of the No.8 Round Sceptre Gold brush to indicate the leaves and twigs and the rough texture within the foliage that provides form and shape. It is a technique that works extremely well on winter trees. Bear in mind the overall shape of the tree.

- You can now concentrate on the finer details of the composition.

- Paint in the doors with a rich mixture of LR and a hint of FU. Add the various shadow effects on all three doors and down the side of the windows. Also add the roof furthest away.

- Add the hedges to the left- and right-hand sides, using a combination of washes in varying strengths to the sunlit areas and shadow. A strong FU mixed with a little LR and a little water can add to the effect by creating darkness, and can also be used for the bushes and foliage at the front of the picture.

- Shadows thrown on to the foreground are created with a dark and very dilute wash in sweeping brushstrokes from either side of the painting to show the undulation in the landscape.

- Use the same wash to paint the background range of hills and give the overall vista depth.

- Complete the picture with bric-a-brac: fences in the background; fence posts and barbed wire in the foreground; the ladder, cartwheel and tools leaning against the cottage wall. Finally paint in birds to bring animation to the sky. All this detail is painted with the No.2 brush using dark washes of FU with a little LR.

This exercise shows that by using the tonal values of just two colours you can create a very effective and dramatic watercolour.

Using washes to define light

Here I explain how washes can affect the light in a painting, and I have drawn two identical cottages to illustrate this effect. A light source is coming from the right-hand side. The direction of the light is indicated by arrows.

In *Figure 1*, the cottage is painted entirely in the same colour wash. The same strength of wash covers the whole building, which is how it would appear on a very overcast and dull day. There is no three-dimensional quality to the building, no real definition.

On a sunny day, however, when the light is strong, a building takes on a more 3-D look, as seen in *Figure 2*. I have used an identical colour wash on both buildings, but to emphasize this

exercise in light, the face of the front wall of the building in *Figure 2* has had two applications of the same colour wash, while the roof has had only one. The gable end wall, which is facing directly away from the source of light, has been given three coats of the same wash.

This process, where the first wash is applied and allowed to dry before a secondary wash is applied, is called *glazing*. In *Figure 2* the secondary wash has been allowed to dry and then a third wash has been added to the gable end wall. This technique has immediately given a three-dimensional look to the building. It is also easy to determine where the light source is coming from.

FIGURE 1

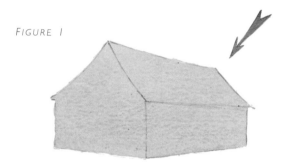

FIGURE 2

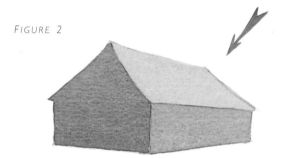

TIPS

- **When viewing a scene for the first time, half-close your eyes. By doing this you will, of course, obscure a lot of the detail in the scene, but you will be left with blocks of light and dark. This is a tonal image, and it is what we should all be aiming for in our paintings.**
- **Make a sketch showing the tonal values of what you can see, and you will find that the shapes in the overall scene are more easily defined. When it comes to painting the scene, you can then decide which areas should be lightened or darkened to achieve the best effect.**
- **If you were to paint all the scene in the same light, it would appear very flat, so I suggest you single out a focal point. Bathe it in light: this will attract the eye to that area, but I don't mean that you have to paint the rest of the picture in dark shades. If you paint a sunlit cottage against a light sky, the building will appear somewhat lost. But if you place a dark tree or mountain range behind that building, the contrast will be much greater. As a rule, the sky tends to be lighter than the landscape. Thankfully, now and again, it can be the other way round, which allows for fantastic contrasts in the landscape as brilliant sunlight floods down from behind the dark, threatening skies.**
- **Observe the landscape well before you start painting. Experiment with your paints, make them lighter and darker, bleed one colour into another, play around with the effects of light and just see what you can achieve. It's well worth it.**

Directional lighting in sketches

Light is not exclusive to watercolour painting. It can be created just as effectively in pencil sketches or ink drawings.

Here is a sketch of Dunsany Abbey in County Meath, which made a very effective backdrop for the movie *Braveheart*. You can see immediately by looking at the picture that there is a sense of light direction. This is achieved by the shading on the left-hand side of the towers and walls. It is enhanced by the diagonal line that shows the play of light on the wall and the line of the shadow cast by the wall. By using pencil shading in this way, a three-dimensional effect is created within the sketch. Shading has been used effectively in the foreground to illustrate that the tree on the right-hand side is casting a shadow across the front of the castle. The play of light on the landscape adds to the character of the composition.

MAKING THE MOST OF LIGHT

The effect of light on the landscape is what makes so many paintings special. Light brings life to a scene.

We artists cannot expect to have sunny days every time we paint. However, with practice and particularly with observation we can learn about the play of light on our subjects and how it affects our paintings.

I have always found that the light in a painting is more effective when complemented with dark. Warm and dilute washes in the sky and foreground areas let the paper shine through. If this is complemented by shadowy, cooler areas, where less of the white watercolour paper is seen, it allows that wonderful glowing effect to happen.

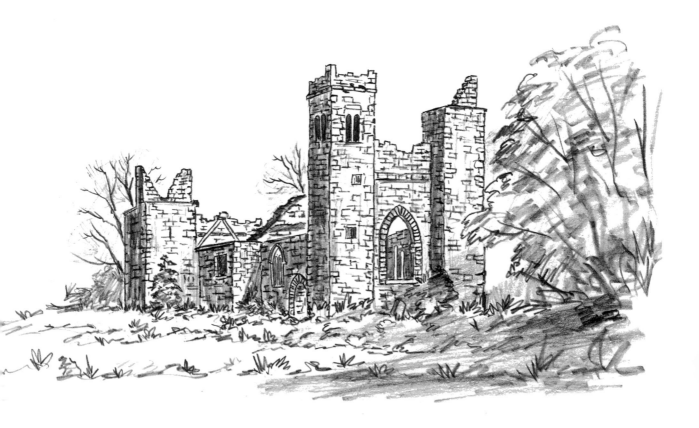

LINEAR PERSPECTIVE

There are two main types of perspective to concern the artist – linear and aerial. Perspective is the main word that confuses the beginner starting out on an adventure of learning to paint. How many times have I heard it said in an art class, 'It's all in the drawing' or 'If I could only draw, it would improve my painting.' These students are quite right: unless you understand perspective, painting can be difficult.

A few years ago, I determined to improve my own drawing technique, so I read up on perspective to help me achieve my goal. After reading several books on the subject, I'm sorry to say that I became more and more confused. In the end, I gave up. However, I did learn two very important lessons from my research:

- To look a lot more at my subject matter and study it intensely. How can I achieve a sense of recession and depth?
- To ask myself questions of the scene I am looking at. How can I capture the moment?

For some time afterwards, I sketched and drew a lot more, and suddenly, by challenging myself, perspective became easier to understand. I came up with a theory: as objects recede from you they appear to get smaller.

This is the simplest possible explanation of perspective. And it works.

Let's try something.

▌ Discovering the vanishing point

Imagine yourself standing on a sandy beach looking out to sea. It is a clear day, the sea is calm, the sky is blue. Now, don't get carried away.

The furthest thing you can see, regardless of your height, is the horizon, where the sky meets the sea. Let's call the line along the horizon the eye-level line.

While you are standing on the beach and gazing out to sea, a yellow brick road suddenly appears before you, which allows you to walk straight to the horizon. Now steady on…

The road looks something like illustration **A** – wide at your feet and appearing to get smaller and narrower as it heads towards the horizon, the eye-level line. It will eventually disappear at a place called the vanishing point on the eye-level line.

Remember: as objects recede from you, they appear to get smaller. We can also apply this rule to three-dimensional objects.

You are still standing on the beach. As you look out to the sea, an old metal tank appears in the distance, floating on the water (illustration **B**). It appears to be smaller on the far side than it is on the near side. In reality the tank is perfectly square.

Follow the lines of perspective as they recede to the horizon and meet at the vanishing point. The same rule applies: as objects recede from you, they appear to get smaller.

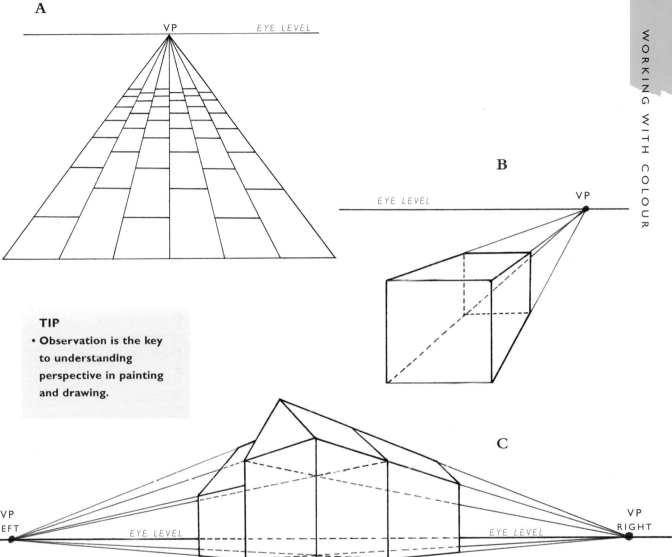

TIP
• Observation is the key to understanding perspective in painting and drawing.

Illustration **C** depicts a three-dimensional object that recedes in two different directions, as do most objects of this kind – houses, boxes, tables, chairs...

This time there is still only one eye-level line, but there is more than one vanishing point. All the uprights are exactly vertical and in reality will be exactly the same height. But on the paper, the nearest vertical must appear to be the tallest.

You will see that the horizontal lines above the eye level are falling as they recede; the horizontal lines below the eye level are rising as they recede. They all come together as they meet the horizon.

Study the drawing carefully and relate it to objects you see all around you.

It's all very well talking about standing on a beach. Imagine you are standing in the centre of a city or in the middle of a mountain landscape. There's not much chance of seeing the point at which the sky meets the sea, from there, but the same rules apply. You have to imagine that you see the eye-level line. Painting is all about imagination anyway. Try this simple exercise.

2 Establishing eye level

Stand up wherever you are and turn to face the nearest wall. As you stand up, relax and look straight ahead, not up or down. Wherever your eye comes to meet the wall, focus on that point and mark it with a pencil.

If you could see the horizon from here, this is where it would be, represented by the pencil line. You will notice that when you look at this point on the wall, everything below this mark you look down upon, and everything above it you look up at.

● In the illustration below the eye-level line is obscured by the trees and mountains, but by gazing ahead you can imagine where it should be.

Study this sketch and you will note:
● From vertical line **A** everything to the right of the sketch is getting smaller
● From vertical line **A** everything to the left of the sketch is getting smaller
● All horizontal lines **below** the eye level rise as they recede
● All horizontal lines **above** the eye level fall as they recede
● All horizontal lines on the eye-level line remain absolutely level
● All upright lines remain exactly vertical

Also note the rise from the bottom of vertical line **A** to the bottom of vertical lines **B** and **C**. Pay particular attention to the chimneys as they are also three-dimensional objects. Although the lines of this sketch follow the laws of perspective, they have not been drawn exactly straight because we very rarely see perfectly straight lines in reality on any landscape.

Practise this simple exercise in perspective and remember all the basic rules.

Take note that the vanishing point to the left-hand side is not on the drawing surface. Vanishing points do not have to be contained within the painting, but as long as you realize this and can work out just where they are in relation to the picture, you should have few problems.

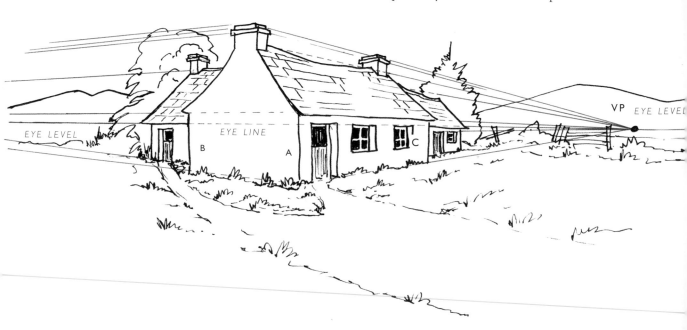

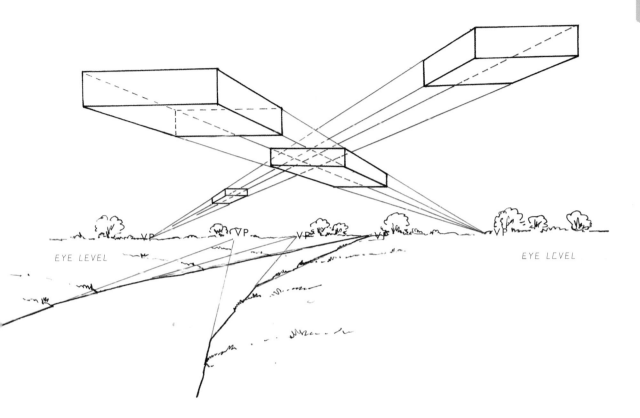

EYE LEVEL

EYE LEVEL

3 Landscape and perspective

The illustration above shows how the landscape is affected by perspective. Even clouds are three-dimensional objects, so they, too, appear to get smaller as they recede.

You will notice in this exercise that there are numerous vanishing points on the picture, but only one horizon.

If you take time to study the sky outside, you will discover that the clouds are often formed in layers, some moving slowly, others moving fast, with layers moving over and across each other. The clouds above you are normally the closest to you and will look larger than similar-sized clouds that are a few miles away. Different layers of clouds might come from different directions and thus have different vanishing points.

Now take a look at the road in the sketch. If it were straight, it would have only one vanishing point. But because there is a bend, you will see that the vanishing point moves along the eye-level line.

TIPS
- **Study all these drawings and practise them for yourself. This way you will soon come to terms with, and understand, perspective. But, please, do not let it become an obsession and put you off painting.**
- **Follow the rules – they are really quite simple – and you won't go far wrong.**

AERIAL PERSPECTIVE

Aerial perspective is used to create a sense of space within a painting. When colours are viewed from a distance, they seem to become less intense and defined. They tend to appear bluer and become paler. The vivid contrast between colours also diminishes with distance. This is caused by dust in the air and particles of moisture in the atmosphere, which diffuse the light so that we do not see the true colour. For painters, it is necessary to exaggerate these changes by making the background and distant objects appear blue to give a sense of space within the painting. If you look closely at paintings, you will notice this effect captured in the sky: it is darker towards the top of the picture. This is because the sky is closer to the eye at this point. As it recedes into the distance on its way to the horizon, it appears to get lighter. The sky at this point is further away and the colours are more diffused.

This example illustrates how a tremendous feeling of depth can be created within the picture. It also shows how aerial perspective comes into play because we can see less of the mountain in the distance than in the foreground, producing a sense of space.

When trying this exercise, it is important that you take every wash to the bottom of the paper. This will create greater depth and intensity of colour in the foreground.

❙ Using colour to enhance perspective

I have tried to illustrate this point with the painting shown here. Several years ago I was in Croatia. One evening I went out into the mountains near to Ljubljana and saw a fantastic scene. It was of a mountain range that seemed to recede further and further into the distance. I have tried to recapture the scene in this sketch, which I believe gives a wonderful example of the effect of aerial perspective.

This scene can be painted very simply using a mixture of FU and LR. Use this wash for the

sky, adding more water as you move down the paper to give the effect of a paling sky receding to the horizon.

When the first wash has dried, paint in the background mountain wash, using a slightly stronger mixture of the same two colours. Apply this secondary mix to the entire area on which the four mountains will be painted.

Thicken the wash with the addition of FU and a touch of LR for a denser mixture. Once the secondary wash has dried, paint in the

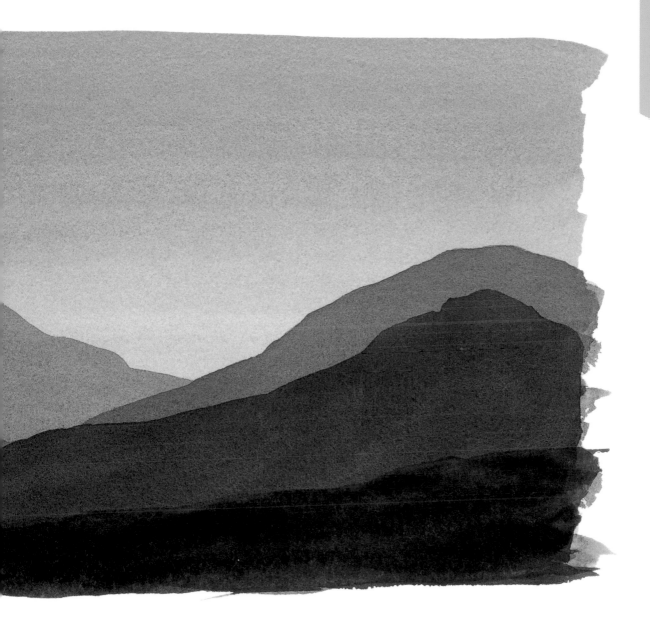

second and third mountains furthest from the back, which will be slightly darker, and allow to dry.

The mixture must be thickened once again, using more of the two colours. Apply it over the area on which the second and third mountains from the back will be painted. The colours will get deeper and stronger to produce a sense of distance.

Finally, add WY to the FU and LR mix and add in a fourth wash for the darker foreground.

The intense colour at the bottom of the painting gives a definite impression of foreground. The second and third mountains from the back have less colour because they are further away – the colours are being diffused, giving a sense of depth. The mountain at the back is a paler blue which adds another dimension to the picture and generates greater depth. Beyond that for the sky there is a lighter, washed-out blue, which adds to the atmosphere.

2 Furthering a sense of perspective

Here is a painting of a lake in County Fermanagh. If you look at the overall picture, you will see that the sky at the top of the painting is very strong and dark, with clouds floating across it. Notice that there is shadow on the underside of the clouds, giving depth. As the sky recedes into the distance it gets paler because it is further away and you can see less of the colour.

The sky is painted with a wash of FU and LR. Once this wash is dry, paint in the mountains using a slightly darker mixture of FU and LR than the sky wash. You can see that the mountains in the far distance are very pale.

The clump of trees to the right of the blue mountains can be added next. By feeding more LR into the mixture you can obtain a stronger feeling and intensity to the colour within the foliage.

Introduce more LR with a touch of WY to the mixture and build up the colour and texture on both banks of land that jut into the middle of the painting at left and right. Also add the background trees. By increasing the amount of LR and WY in the wash, more defined colour and detail can be shown.

Now more of the real colours can be flooded into the foreground: the variety of greens gives texture and definition and brings the foreground alive. Concentrate on bringing this detail out to lend to the atmosphere.

Finally, paint in the water and shadows. The defined colours feature strongly towards the front of the painting. As the water recedes into the distance, it gets paler, which gives a definite feeling of space and depth.

Once all the washes are dry, paint in the finer details, including fenceposts and birds, as finishing touches.

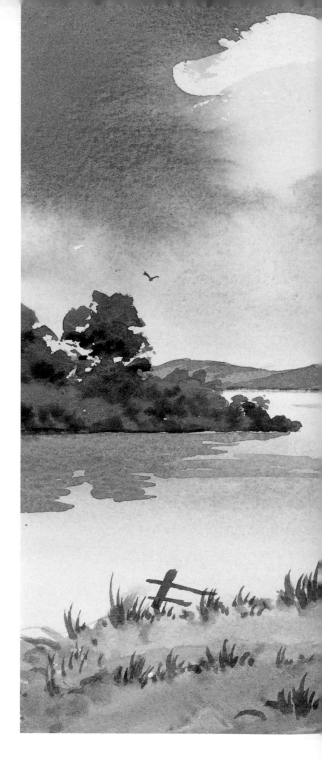

This is how to use aerial perspective within a painting to give depth and space. The stronger, more defined colours are found in the foreground, and the paler, less intense colours further back. As you look at the whole painting you will see the full impact of the composition, with the view receding into the distance. This method can also be used very effectively to paint buildings, pastures and fields, trees, clouds and snow scenes – indeed, anywhere you want to create space and depth to bring a sense of atmosphere to your painting.

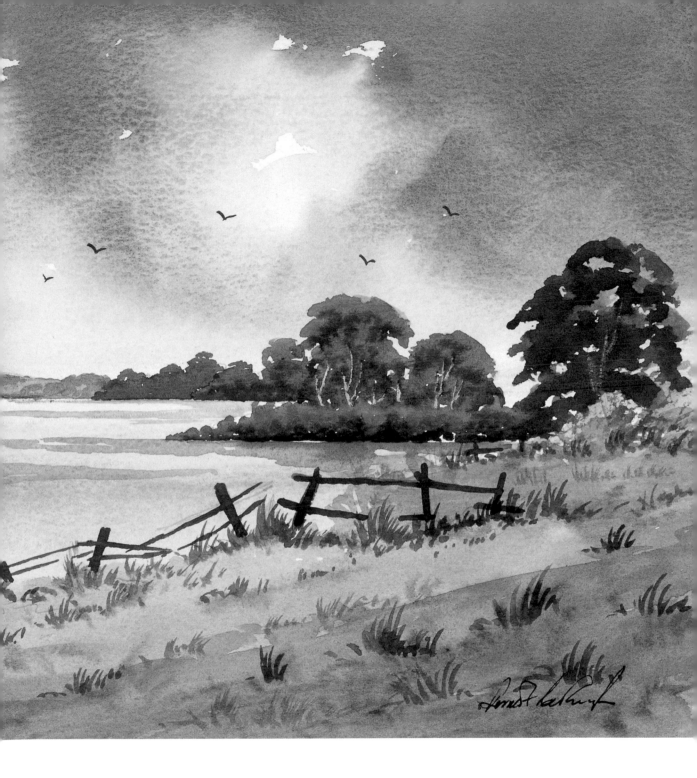

BRUSH CONTROL

There are no great mysteries to watercolour painting. It is really all about confidence and practice. One of the first things I encourage students to acquire is good brush control and technique, as these are essential requirements for good painting. It is very easy to pick up the rudiments that will allow you to enjoy painting, but practice, as they always say, makes perfect.

When practising brush techniques, you should doodle as much as possible. Do not try to paint a picture right away. Simply paint lots of shapes, squiggles, vertical and horizontal lines and grids. Then try to use all these elements by attempting simple detailed work, such as gates and fenceposts, trees, foliage, grassy banks, ladders, cartwheels and all kinds of building.

Here are a few simple exercises and tips that will help you to get to grips with the recommended four brushes and to develop brush control and technique. You can use each of the four brushes to practise the same exercises: painting grids, horizontal and vertical lines, trees, grass, fences and sky formations. Each brush has its own unique feel and style, and each will give different results.

The 19mm (¾in) Flat Sceptre Gold brush

Use this brush with a very dilute wash to paint skies and cover broad areas quickly. This exercise shows how billowing clouds can be produced using the mixes we put together on pages 20–25.

- Use a dilute mixture of RS and water to form the cloud shapes (1). While the wash is wet, add a mixture of FU, LR and AC – in a mid-bodied consistency – to highlight the shadowed underside of the clouds.

- While the paper is still wet, paint the sky around the top of the clouds with a mixture of FU and only a small amount of LR. As the three colours merge, the paint will run and spread. Wash the brush and half dry it, then blend the washes together. Let the paint dry naturally to give a wonderfully effective billowing cloud mass.

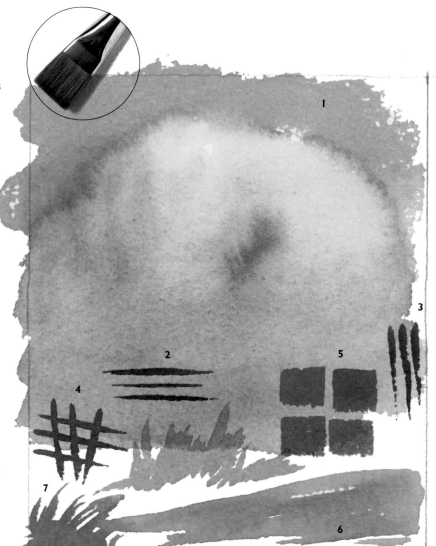

Now try this...

- Using a thicker paint mix of WY, WB and LR, the brush can be used to great effect. Draw the chisel edge of it across the paper to produce a series of horizontal lines (2).
- Turn the brush into the upright position and, using the chisel edge once more, pull the brush down on the paper to produce a series of vertical lines (3).
- By combining the two simple exercises you can create a three bar fence (4) and heavy trellis work.
- Place the brush flat against the paper and bring it down in one stroke to create a large,

single window pane. Repeat the procedure and you can easily paint the four squares of the window. Leave the paper exposed to form the frame (5).

- For foreground areas, to show the direction in which the land is falling, hold the brush as you would a pencil and pull it across the paper in long, downward, diagonal sweeps from right to left (6).
- For grass effects, bring the brush into the vertical position and push it upwards in short strokes, flicking the hairs against the paper to produce blades of grass (7).

The No.8 Round Sceptre Gold brush

The illustrations below show the effects that can be achieved using this particular brush.

• Load the No.8 Round Sceptre Gold with a mix of FU, AC and plenty of water. You can cover large, flat areas (1), such as for skies, very quickly and effectively with just one or two strokes.

• In illustration 2, paint the roof by drawing the brush along the ridge of the house and pulling it down in the direction of the fall, as if you're repeatedly painting the number '7'. You will see that it covers the area very quickly. This brush is also used to paint in the very fine corner lines of the house.

• Now turn the brush on its side and, using a mixture of WY and WB, drag it in a semi-dry state over the rough surface of the paper. You will see that the brush deposits paint with a broken edge to give the outline of the tree (3). If you feed more paint from the centre of the brush on to the paper, you can fill out and shape the bulk of the foliage (4). However, you must leave plenty of space for branches and foliage, and holes through which the birds can fly.

• Leave the paper to dry and then, with the pointed brush containing a mixture of BS and NT – a splendid brown – add in the tree trunk. Finally, use the point of the brush to paint in the branches in the spaces you have left.

• The point of the brush is also very handy for making fine lines. Create a grid effect (5) by flattening the brush and turning it on to its side. Use the chisel edge and pull it down on the paper in a series of vertical sweeps to form uprights. Turn the brush around and pull it across the paper from left to right to form horizontal lines.

• Now use the point of the brush once more to create fenceposts (6) by painting vertical and horizontal sweeps as for the grid. You will notice that these particular fenceposts are not sitting up straight, they lean to the left and right and look uneven. That simply adds to authenticity: you rarely find perfectly straight fences in the countryside.

• As with its bigger sister, the 19mm (¾in) Flat Sceptre Gold, the No.8 Round is perfect for painting window panes (7). Use a single stroke for each pane of glass.

• If you use the brush in a horizontal motion, it will give a wonderful effect of water with ripples and sunlight (8).

• Finally, to paint the naked tree trunk (9), sweep the brush in an upwards movement – the direction the tree grows. By lifting the pressure off the brush as you move upwards, you will achieve a tapering effect as the brush returns to a point.

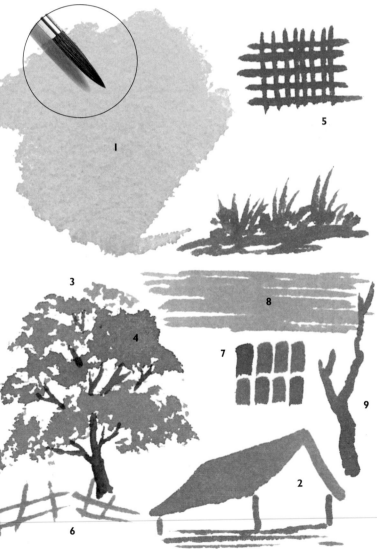

The No.5 Cirrus Sable brush

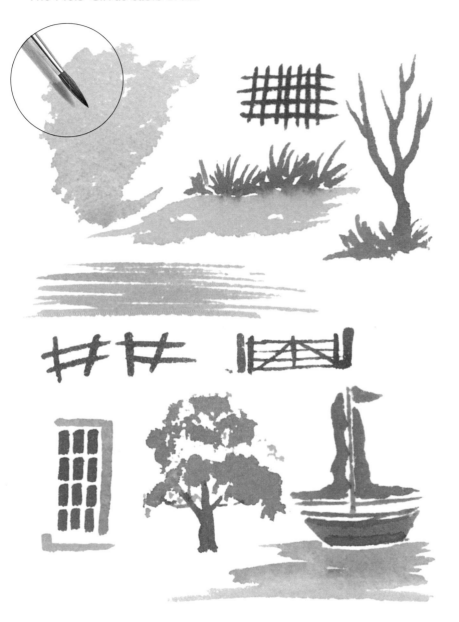

TIPS
- **Paint lots of little pictures, such as those on this page, using all the brushes. And sign your name with the brush.**
- **Experiment with your washes and find out exactly what can be achieved with each brush. You will soon have a favourite. Then try to paint an entire picture using just one of the brushes.**
- **Spend hours doodling too, trying out the different brushes and gaining confidence with your brushstrokes and techniques. It will improve your painting no end.**

The No.5 Cirrus Sable will produce far more delicate and intricate work. Foreground trees needing more defined detail, grassy areas, foliage and water are perfect for this brush. The chisel edge, when the brush is flattened, creates the fine lines for the grid, the fence and the gate. While handy for more defined objects, such as the boat, this brush can also be used to cover large areas with the minimum of effort, as in the top illustration.

- Load the brush with a very dilute mix of FU, LR and AC, and draw it across the paper, putting pressure on the brush, to create your wash.
- For the foliage on trees, turn the brush on its side and with a colour mix of WY and WB. Hold the brush so that the hairs are parallel to the paper and drag them across, moving in a downward direction and remembering to give balance to the tree foliage.

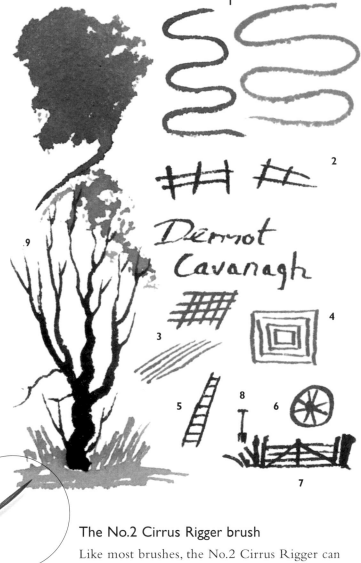

The example of fence work (2) is much finer than earlier versions. Take one stroke for each vertical line and one for each horizontal line.

- A way of getting used to this particular brush is by signing your name with it time and time again. This is something you should be able to do without even thinking. If you keep trying, you will soon have total control over the brush.

- The illustrations in the bottom right of the picture show you just how fine the point is on the Rigger. Practise the grid system (3) with single downward strokes for the vertical lines, and across from right to left for the horizontal. Then try experimenting with a variety of shapes: squares (4), oblongs, triangles. Next have a go at painting a ladder, a cartwheel, a fence or fork (5, 6, 7, 8). Paint the ladder in exactly the same way as the grid: one stroke for each of the vertical lines, one for each of the horizontal.

- To paint the tree (9), load the brush with a mixture of BS and NT for the brown of the trunk. Now push it flat against the paper with about 6mm (¼in) of the brush touching the paper and move upwards in a zigzag line to create the centre of the tree. Lift the pressure off the brush to create a tapering effect. I always recommend that you paint a tree from the bottom upwards because it creates a natural look.

When you have finished the trunk, take the branches out from the main body of the tree, moving first to the right for each individual branch. Remember to take the pressure off the brush once more as you complete the movement to get that tapering effect. Repeat the operation on the left-hand side, sweeping the branches in one movement. The centre or leading branch is nearly always going to be the highest point of the tree, so use the Rigger until it comes to a fine point at the very top.

Now turn the brush on its side and, with a mix of WY and WB, paint in the leaves and foliage by dragging the brush over the rough surface of the paper.

The No.2 Cirrus Rigger brush

Like most brushes, the No.2 Cirrus Rigger can be used to paint a broad wash very quickly when loaded with water. You need a lot of water in the mix and by moving the brush backwards and forwards on the paper from left to right, you can fill in large areas of the painting very easily.

- The beauty of the Rigger is that the longer hairs allow it to have a lot of play, perfect for making snake-like lines (1). You can achieve these simply by moving the brush downwards from the top of the paper, weaving from side to side in equal sweeps. The hairs will turn without spring to give a uniform line.

BLOCKING IN

It is only by practising brush control that you will be able to paint quickly. In watercolour, the quicker you paint the better. Here are a few exercises with shapes that will help you to improve your skills and sharpen your technique. Draw any shape – a circle, square, clothes-peg, spoon, knife, anything that comes to hand – and then block it in with a colour wash. Most painting in watercolour is blocking in.

Square: Start by painting along the top and about 1cm ($\frac{1}{2}$in) down the side and fill in that area. Then continue to bring the brush down. Repeat until you finish the shape. It is inadvisable to draw a complete outline to start with because it will have dried by the time you fill in the whole shape and you will be left with an inconsistent colour with light or dark patches.

Set Square: Sketch the shape in pencil. Start at the top tip and fill in down towards the inner triangle, working from left to right. This might seem difficult to get used to at first.

Wherever you leave your leading edge (your last brushstroke), you are going to have a dry line, so you must work quickly. Keep filling in both sides of the shape at the same time, working from the point of the inner triangle to the base of it. Block it in quickly so that no area dries.

Circle: Start at the top. Pull down a stroke curving to the left, followed by a stroke curving to the right. Fill in the centre, then make more curving strokes to left and right to complete the circle. Fill in the whole shape in this way as you move down.

Protractor: Start at the top. Pull down to the left, pull down to the right and fill in as you go bringing it down like a flat wash as you progress.

Ruler: Start at the top. Come down about 2.5cm (1in) at the side and fill in the area. Continue the process, painting about 2.5cm (1in) at a time as you would for a graduated wash or flat wash until you reach the bottom. If you leave a wet line along the bottom (that's a bubble of paint) and let that dry naturally, it will bleed back up into the drying wash. Whenever you come to the bottom, squeeze the wash out of the brush between your fingers and thumb, then dab up the loose water.

Skyline: Learning how to block in a skyline is extremely useful because you need to cut around many objects, which requires great skill and control. Practise this exercise a few times and you will improve enormously.

Start with the wash at the top left-hand side and bring it down to the roof and up around the chimney. Go down between the two walls, then go back up to the second chimney. Work quickly until you complete the task.

LAYING A WASH

A wash is a term given to almost everything we do in watercolour painting. Some washes are very fluid or dilute, some are less dilute or mid-bodied, others are thicker or full-bodied. The more water added to a mixture or wash, the more dilute it becomes.

Drying times will depend on several things: the amount of water that is in the wash, the ambient temperature in which it is being applied and the type of watercolour paper being used. The hotter and drier the environment, the faster the drying time.

Working wet on dry and wet in wet are among numerous terms applied to washes. Which do I prefer to work in? All of them – wet in wet, wet on dry, wet into not-so-wet and wet into almost dry …and all in the same paintings.

As a general rule, my skies will be wet in wet and my foregrounds will be wet into not-so-wet.

• My trees, foliage and mountains will be wet into not-so-wet and wet into almost dry.

• My stonework and building surfaces will be wet into not-so-wet or wet on dry.

• My shadows and finishing details will be wet on dry.

Here and overleaf are examples of some of the washes I use. Try them out and practise them. Get to know drying times so that you can judge when washes are not so wet, almost dry and dry.

▌ Flat wash

A flat wash is used to cover a broad area of the painting surface, with the colour remaining exactly the same throughout. There is no grading or graduation and the wash does not change colour during its application, which must be done quickly. This sort of wash may be used as the basis of the wet on dry technique. The example above is created with a mixture of FU, a touch of LR and a large helping of water, to produce a mid-bodied wash. It is applied generously with the No.8 Round Sceptre Gold brush.

With the drawing board set at an angle of 15 degrees from the horizontal, draw the brush across the top of the paper from left to right, forming a well of water along the bottom of the wash line.

Quickly go back into the mixture, take on more of the wash and draw the brush across again from left to right. Work downwards from top to bottom.

The well of water at the bottom of the wash line keeps moving down with each stroke and therefore does not produce hard lines or variation within the colour of the wash.

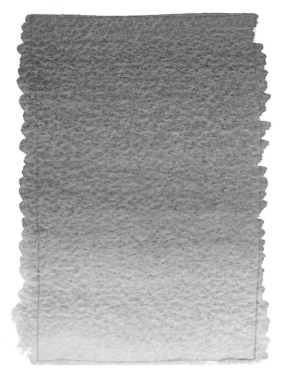
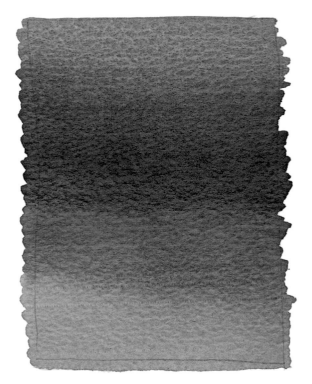

2 Graduated wash

This graduated wash is initially created in exactly the same way as the flat wash, using an identical mid-bodied mix.

Draw the brush across the paper from left to right, forming a well of water along the bottom of the wash line as before.

However, each time you go back into the mixture to apply further strokes, take an extra helping of water with each application, which will reduce the concentration of the wash as you move down the paper. The wash will be darker at the top, getting lighter as it reaches the bottom.

This wash is very useful for painting blue skies, particularly the recession in them, where the colour is more diffused.

3 Colour graduated wash

This is an ideal technique for painting sunsets because it allows for colour change from one level of the sky to another. As with the other two washes, the colour graduated wash may also be used as the basis of the wet on dry technique.

Using the same mid-bodied wash of FU and a touch of LR, draw the brush across the paper in exactly the same way as before to eliminate hard lines.

As you move down the paper, working from left to right, gradually introduce some AC into the mixture. The crimson will blend with the blue to create a purple shade.

Move further down the paper and introduce WY into the mixture. When the WY is mixed with the AC and the FU/LR wash, a brownish-purple colour is produced, but as the yellow starts to dominate the wash, it becomes brighter and more intense towards the bottom of the paper.

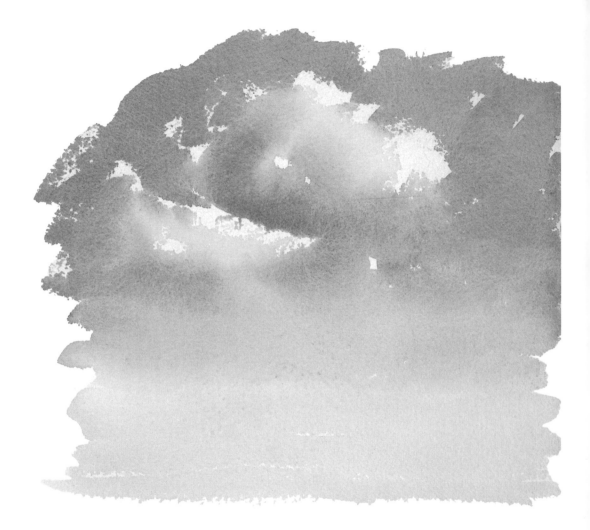

4 Bleeding wash – wet in wet

This is a perfect wash for painting cloudy skies.
Start by partly wetting the paper to create the basis for the
wet in wet technique.

Apply a wash of RS and water in a very dilute mixture to
the lighter areas of the sky and clouds.

While this is wet, apply a dilute mix of FU with a touch
of AC, feeding it into the underside of the yellow wash. Brush
with horizontal strokes across the centre of the sky area.

Work in the sky shape around the top of the clouds, using
a mid-bodied wash made up of FU and a small amount of
LR. Blend the two together, leaving some of the paper
exposed to form white, fluffy clouds. Because the paper and
the washes are wet, the colours will merge together nicely
and bleed into each other.

With the mix of RS and water, taper the wash out towards
the bottom of the paper to give a smoothing effect.

TIPS
- **Always mix your washes before you start painting.**
- **Always mix enough wash to allow you to complete the job in hand.**
- **Use a large brush, such as the 19mm (³⁄₄in) Flat Sceptre Gold, for painting in skies.**

6 Bleeding wash II – wet into not-so-wet

This wash is used for conifer trees and for dense shadows within trees.

Introduce a mixture of WY and WB to the paper and allow it to dry momentarily.

Now feed a secondary mixture of WY, WB and LR – in a slightly thicker wash – into the not-so-wet first wash and allow it to bleed.

While this is drying, add a mixture of FU and LR to create the very dark areas within the trees. Leave to reach an almost dry state.

When dry enough, scrape a penknife blade on the paper, moving upwards and tapering as you go. This will give the dramatic effect of trunks and branches against dark foliage.

5 Bleeding wash I – wet into not-so-wet

This type of wash is used for painting trees when you need to create a soft edge by putting a dark colour into a lighter one. It is also used in foregrounds to give the effect of tufts of grass and texture by bleeding one wash into the other.

Apply a full-bodied wash of WY to the paper with horizontal brushstrokes. The mixture should contain a lot of colour and little water, but must still be fluid and liquid.

Dip the brush into a full-bodied wash of WB and simply touch it into the centre of the yellow wash, which is drying.

You can see from the illustration above how the WB has started to bleed through the yellow in its not-so-wet state. This stops spreading as the yellow wash dries. It gives a distinctive edge to the wash.

7 Bleeding wash III – wet into not-so-wet

This wash is used to give a distant look to trees and to show dense shadows within them.

Use the 19mm (¾in) brush to apply a mid-bodied wash of FU and LR to the paper. Start at the top and work to the bottom. As you move downwards, introduce more LR into the mix. It will change the colour as it blends and merges into the wash.

Bring the wash down to the grass line.

Now feed a thicker, full-bodied mixture of FU and LR into this drying wash. When this new mixture is introduced, it will start to 'explode' and bleed upwards into the drying wash to give the soft top-of-the-tree effect.

TIPS
- **The first wash must be midway through its drying process or the secondary wash will bleed too far. Remember to use the test paper (page 25) to determine the wetness of your washes.**
- **The secondary wash must be slightly thicker than the first wash, otherwise it will bleed through it completely.**

The secondary wash will spread slowly before stopping abruptly as the paper dries.

A further full-bodied mixture of FU and LR should be applied towards the bottom of the trees above the grass line to give shades of light and dark within the secondary wash.

Just before the painting is dry, use the side of a penknife to show the trunks by scratching back the paper, flicking upwards to remove some of the paint. If the wash is not in an almost dry state, the mixture will bleed back into the white area exposed by the penknife, so wait a little longer. In the almost dry state the wash is drying so quickly that it does not get a chance to bleed back.

When this wash is totally dry, use a mixture of WY and a touch of WB in a mid-bodied wash, brushing it across the paper from right to left to form the grassy foreground below the tree line.

While this wash is in its not-so-wet state, apply a secondary mixture of WY with more WB added. Brush across from right to left to give texture to the foreground.

TIP
- **Always keep a separate piece of the same paper you are working on by your side when you are painting. This is your test paper and you need it for several reasons. If, for example, you are painting a tree and intend to feed a wet wash into a not-so-wet wash or an almost dry wash, apply the wash to your test paper just before you introduce it to the painting. With the secondary wash on the brush, keep touching this experimental wash on the test paper with the point of the brush until it looks as if it is going to do exactly what you want it to do. At that time, the first wash you applied to the painting will be ready to work on.**

8 Bleeding wash IV – wet into not-so-wet

This wash is used for trees when you want to show them as well defined and in more detail.

Mix a combination of WY and WB to produce a mid-bodied light green wash.

Apply the wash to the top, middle and bottom of the tree's foliage areas, using the No.8 Round Sceptre Gold brush turned on its side and drawn across the rough surface of the paper.

Still using the side of the brush, feed a secondary mixture of WY and WB with a touch of LR on to the underside of the foliage areas in the first wash.

While this is drying, apply a third mixture of FU and LR in a full-bodied wash to the bottom of the same three foliage areas.

As each wash is introduced, the colours will bleed and pull, merging to give a soft-top effect associated with tree foliage.

Once the foliage areas have dried, apply a wash of FU and LR in a full-bodied dark brown mixture using a No.2 Cirrus Rigger. Paint the tree trunk and branches in the spaces between the three areas of green. Flick the brush upwards, tapering as you progress, to build up the structure of the tree.

When this is completely dry, return to the mixture of WY and WB with a touch of LR and paint in the foreground from right to left using the 19mm (¾in) Flat Sceptre Gold brush.

While the wash dries, feed in a secondary mixture of WY, WB and LR in a slightly thicker mix to give texture to the foreground.

9 Bleeding wash V – wet into almost dry

This wash is used for trees when you want to restrict the bleed of the secondary wash, as illustrated on the undersides of the branches.

Create a small conifer tree using an initial mid-bodied mixture of WY and WB to produce a very light green.

When this is almost dry, mix a secondary wash of WY with more WB added to make the mix thicker and more full-bodied. Feed this into the right-hand side of the tree to make it darker and give the effect of light coming from the left.

TIP
• **If the paper feels cold, the chances are that the wash is not yet dry.**

PUTTING WASHES INTO PRACTICE

Here is a series of paintings that uses a combination of washes. You will need to refer back to earlier exercises to produce the best results.

Country scene
- The sky is created using the same technique described in Exercise 4, page 48.
- Let the sky dry completely.
- The tree is painted on to a dry background (the 'wet on dry' process), but several other techniques are involved in completing it (Exercises 8, 5 and 6, pages 49–51). The trunk of the tree and branches are applied in the same way as Exercise 8.

- When the tree is finished, bleed in the hedgerow using a mixture of WY and WB to create a mid-tone green.
- As this dries, feed in the foreground grass (as in Exercise 7, pages 49–50), which is produced with a combination of WY and WB in a very light tone of green.
- While the foreground is still damp, bleed in the texture, using a mixture of WY with more WB added to the secondary wash.
- Add the background hill, using a mixture of FU and LR in a very dilute wash to give the feeling of recession.
- Wait until all the other washes, particularly the background hill, have dried completely, before painting the gate or it will bleed into the background and look messy. Use a full-bodied mixture of BS and NT to make a dark brown for the gate. (LR with NT works just as well.)

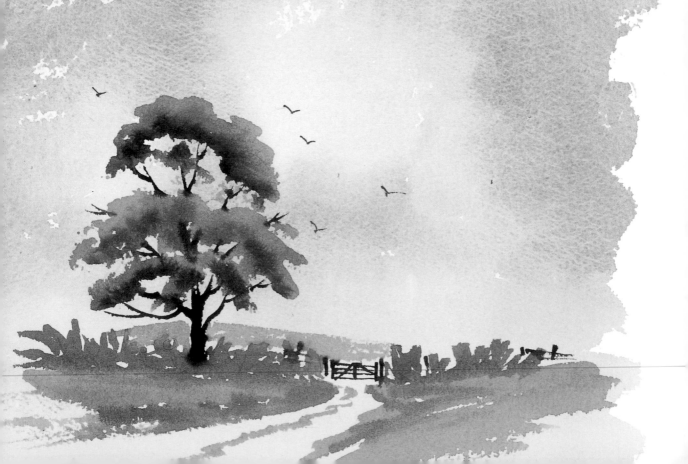

Stone cottage

- After sketching the stone cottage in pencil, paint over the walls with a dilute mixture of RS and water.
- While this is in the not-so-wet state, add a mixture of LR and RS in a thicker, mid-bodied wash and paint in a few selected areas of the stone wall for texture. Let this dry completely.
- Using a mixture of BS and a touch of FU, add stone effects to the gable end and the front wall of the house. This must be carried out with wet paint on dry paint (a process called glazing), otherwise the stone effects will bleed into the previous wash.
- After this has dried, paint in the roof of the cottage, using a mid-bodied wash of FU and LR. Pull the brushstrokes in a downward diagonal direction following the fall of the roof. Leave the brushstroke broken at the bottom and when in a not-so-wet state, feed in some WY. The WY will bleed into the FU and LR to give the effect of lichen growing on the roof. It will bleed upwards and merge with the other wash.
- When the roof is dry, the ridge tiles should be painted in using LR.

- Next add the darkness of the doorway and window panes using a full-bodied mixture of FU and LR.
- When the cottage has dried, you can go to work on the foreground. Use the No.8 brush with a wash of WY and a touch of WB that produces a light green, pulling across in horizontal strokes. While this is drying and in a not-so-wet state, bleed in another mid-tone mixture of FU and a little WY that produces a darker green. This will merge with the lighter green and give texture.
- Finally, paint in dark shadows under the eaves, beneath the roof tiles on the gable end wall and the front of the house, with a wash of FU and LR.
- Further character can be given to the cottage by changing the direction of light and adding shadows. This is achieved with the wet on dry or glazing technique.
- The gable end wall and the foreground must be completely dry before you start painting. The shadows are produced using a mixture of FU and LR. Remember that working wet on dry produces hard lines.

TIPS
- **If you paint wet on dry, you will get hard lines.**
- **If you paint wet into wet or wet into not-so-wet, you will get soft lines.**
- **If you paint wet on almost dry, you will get 'hairy' lines.**

Country pathway

• Start painting the pasture on either side of the pathway in the foreground using a very dilute wash of WY and WB, which produces a pale, yellowish-green.

• While this is in a not-so-wet state, bleed a secondary mid-bodied mixture of FU and WY into the foreground to give a grassy, textured effect to the pasture. Use sweeping brushstrokes to show the directional fall of the bank on either side of the pathway.

• When this is dry, introduce shadow to the right-hand side of the painting with a mixture of FU and LR. When brushed across the green, this wash will change colour because it is influenced by the mixture underneath. An impression is created that trees and foliage out of sight on the right-hand side are casting shadows across the foreground.

• Next, paint the hedgerow using an initial mix of WY and WB, followed by a thicker mix of WY, WB and LR. The secondary wash bleeds partially through the first to give a feeling of texture in the foliage.

• The fence is painted wet on dry using a mixture of BS and NT and a No.5 Cirrus Sable brush. Remember: do not paint in the fence until all the other washes are completely dry. This prevents bleeding and ensures that the posts remain solid.

• Finally, paint in the pathway using a mix of RS and a tiny amount of AC in a very dilute mix. Pull the brush back from the furthest point of the path towards the source to give the lines and show the direction of the path. While this is in a not-so-wet state, bleed in a mid-bodied wash of FU and AC, pulling the brush back in one stroke. Squeeze the hairs of the brush

between your finger and thumb, then blend in the shading of the pathway in the right direction to illustrate that it bends away around the corner at the top of the paper.

Try this

• Apply a dilute wash of WB and water.

• Now feed a full-bodied wash of NT and water into the blue.

• Into this secondary wash introduce a full-bodied wash of LR.

• Finally, bleed a full-bodied wash of NT into the wash of LR. All the washes are fed wet into wet and allowed to dry naturally.

What does it look like? I suppose it could represent a stormy sky, but in reality, it was a total experiment. Play around with washes all the time and see what effects can be created and what surprises emerge through the colours. Get used to the drying times and find out what happens whenever the wash hits the paper. You'll be amazed at what can be achieved – and what you can produce with a little practice.

PROBLEMS THAT ARISE WITH WASHES

Here are just four problems that can happen whenever you are laying down a wash.

1 Streaky flat wash

The wash is streaky, with 'flowering' at the top where it has bled back into a drier area. What went wrong?

A wash of FU and water in a mid-bodied mix using the 19mm (¾in) brush has been applied. The problem develops if you start from the top of the page, using horizontal strokes from left to right, and then move down over the paper, but leave too much time between each stroke. When you get to the bottom, the wash is uneven, so you attempt to correct it by working back upwards again. By this time the wash at the top is almost dry, which makes the overall effect streaky.

2 Bleed back

This is what happens when you have a perfectly good flat wash, but do not wait long enough for it to dry before feeding in the foreground.

You can see that as the green wash has been applied to the flat wash, it has 'exploded' up into it. This technique is called bleed back. It's a horror story when you don't want it to happen, but you can use it to your advantage if you are painting a distant range of trees or hills and you need to create a soft, uneven top. Perhaps, not surprisingly, the technique is very difficult to produce to order.

3 Running out of wash I

This time a mid-bodied wash of FU and water has been mixed and the paint applied across the paper and down in horizontal strokes to create a flat wash. It was going well until, half-way down the paper, the paint ran out and had to be re-mixed. It is almost impossible to create the same wash twice because there is no way of controlling how much paint goes into it. The secondary wash was slightly darker than the first and more full-bodied.

Several minutes were spent mixing up this second wash, by which time the applied wash was almost dry. You can see where the line has bled. The bottom of the wash is much darker than the top.

4 Running out of wash II

Another example of mixing up too small a quantity of wash. A flat wash is being created while working down the paper when the mixture runs out. To avoid repeating the same mistake, the wash is stretched by eking out the mixture. You can see that the colour has changed as the paint has dried. There is just not enough paint on the brush to give that nice fluid movement across the paper. It becomes streaky and the white of the paper shows through.

The basics of painting

COMPOSITION

Learning about composition is a very important part of learning to paint. Whenever you go out into the landscape and choose a subject to paint, the first thing you have to do before starting a sketch is to plan how to compose the scene: what to leave in, and what to take out for better balance and a more pleasing picture.

It's often said that you should paint what you see and not what you think you see. This is basically correct, but rules are made to be broken, or bent slightly anyway. Sometimes if you paint exactly what you see, the composition might be wrong and therefore the finished painting will not be pleasing to the eye. From time to time, you will need to change things around a little to balance the picture and make it more interesting. For example, there might be a conflict of interests in the foreground and no obvious focal point; or too little sky.

At first it can be difficult to decide what to include, but with experience you will soon be able to determine exactly what you need to make a good composition.

It's a good idea to use a view finder initially. This is a piece of mount card measuring 200 x 150mm (8 x 6in) with a hole that is 150 x 100mm (6 x 4in) cut into it. View the scene through the hole to help you decide how much of it you'd like to paint – viewing the scene at arm's length you will see less of the scene that at close up. After a while you will not need to use the view finder.

Here are six examples of paintings where the composition is not all it should be. Each has been corrected to make the paintings more pleasing to the eye, but there are no hard and fast rules about how to do so. Here are a few ideas that might make you think about composition in a different light in future.

Please do not think you have to change every scene you encounter to make it better. Most of the time nature will have done a pretty good job for you. Use your discretion as to how much you adapt what you see.

Creating a focal point

Before: A pleasing, but simple scene. There are a few mountains in the background and a path leading the eye into the focal point and a tree. But you can see that the tree is positioned right in the centre of the picture, dividing the painting in two. As a result, the eye viewing the picture is confused. It just does not know where to rest or where to focus, and keeps jumping back and forth, looking to right and left: it thinks it is looking at two different paintings.

After: Now the path leads the eye into the painting from the left-hand side, and the hedgerow on the left leads to the tree, which has been moved slightly to the left. The other side of the picture has been balanced by a cloud in the sky and a bush, which stops the eye drifting out of the painting on the right.

TIP

• When painting a landscape of this type, always keep the horizon slightly below half-way because if you are looking at a scene, you must be able to decide if you are more interested in the sky or in the foreground. If you position the eye-level line exactly half-way up the painting, the eye will not know what it should be looking at – the sky or the foreground.

Balancing a picture

Before: Here is a country cottage scene. But even though the horizon line is in the right position (slightly below half-way), the building is too central to the painting. The tops of the mountain, tree and cottage, are all more or less in line, so they all run very straight and look boring. Furthermore, the lines of the mountain in the background lead the eye out of the painting on either side.

After: The cottage has been moved to the left-hand side of the painting and the pathway still leads the eye to the focal point. The tree added on the right-hand side balances the cottage. The tree behind the cottage is now larger than the building and helps define the outline. Look, too, at the mountain behind the cottage. It comes into the picture about a third of the way up the tree, and the top of the cottage is now between the top of the mountain and the top of the tree.

Avoiding confusion

Before: The composition in this scene is totally wrong. The path leads in from the right-hand side and the horizon line is centred on the paper. Furthermore, the painting has been divided in two because the two similar cottages and trees on opposite sides of the picture compete against each other for attention. The eye is brought into the picture by the pathway, which splits, so the eye doesn't know whether to look to the right or left. It continues to bounce back and forth between the two cottages, searching for a definite focal point.

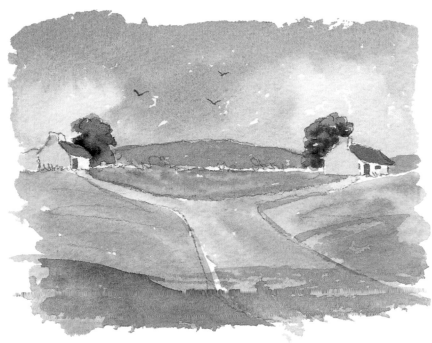

TIP
• If there is lots of detail in the foreground, there must not be a lot of interest in the sky because it will distract attention and compete with the focal point.

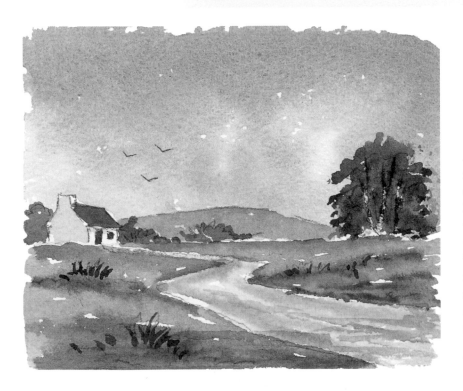

After: One of the cottages has now been removed. The path still leads in from the right-hand side and zigzags into the middle distance, leading the eye towards the cottage. The horizon line has been moved below the half-way mark and the cottage is surrounded by dark trees to make it stand out. The large tree on the right-hand side balances the painting.

Creating the third dimension (3-D)

Before: This is a nice composition, and there are several good points. The pathway comes into the painting from the left-hand side and leads up to the cottages. Although the horizon line is below halfway, the mountain, the trees and the rooftops are not all at the same level. However, the scene isn't totally right: it looks very flat and does not inspire. There is no depth in the painting and no sense of a third dimension.

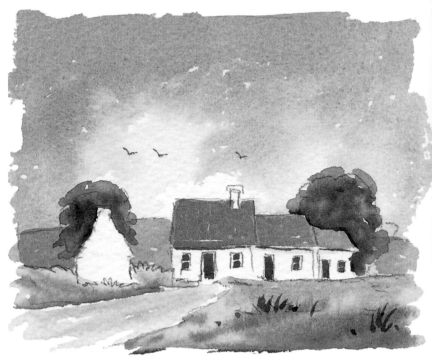

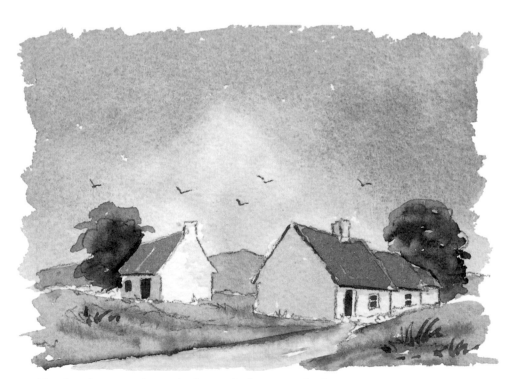

After: By changing the angle from which you are looking at the scene, impact is brought to the composition. The cottages are far more pleasing to the eye now that you can see both the side and the front walls of the prominent buildings. The slope of the land, now clearly visible, also adds more interest to the foreground. You get the feeling you could walk into the painting and around the buildings.

Making the most of a path

Before: Here you can see a pathway leading through the Donegal countryside, passing two thatched cottages on the left-hand side. It is quite an attractive scene with the mountains in the background. However, the main problem with the composition is that the pathway leads the eye in from the left-hand side, then very quickly leads it out again at the right, ignoring everything in the middle.

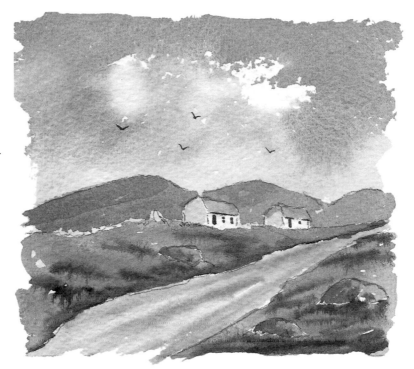

TIP
- **A path or roadway should not lead directly into the picture from one side and straight out again on the other because the eye is led out of the painting. Paint paths, roadways or railway lines so that they start slightly above or below the corner of the page.**

After: The original painting has been corrected by bringing the path into the picture from the right-hand side. Instead of being straight, it zigzags between the rocks, getting smaller as it leads into the distance, and disappears over the brow of the hill. The path now takes the eye right into the focal point. The horizon line has been lowered slightly below half-way, and the clouds on the right-hand side balance the cottages on the left.

Creating a sense of balance

Before: Here is a wide open lake with a big sky, and on first inspection there appears to be little wrong with this picture. The horizon line is slightly below half-way, and a large landmass comes into the picture from the left-hand side and is very pleasing on the eye. The problem is that the painting lacks balance. All the action is taking place on the left-hand side and the right-hand side is bland as nothing is happening there.

After: By moving the large, dark cloudmass from the left to the right of the picture, the painting is immediately improved. You can see the cloudmass reflected in the water, bringing a darkness and interest to the right-hand side that was missing before.

SKIES

Skies can be a very effective part of any painting, creating tremendous atmosphere. Here are four different types of sky, all of which are simple to produce. However, before you start to paint, here are a few handy tips for better results.

• Use a large brush – the 19mm (¾in) Flat Sceptre Gold is ideal – and use plenty of water in your washes.

• Partly wet the paper first with plain water to prevent your washes from drying too quickly. Always keep your painting surface (that's your painting board) at about 15 degrees from the horizontal.

• Always mix the colours before you start painting skies, and make enough at the beginning so that you do not have to mix more once you have started painting. You might never be able to mix the same wash twice, and by the time you have made the second mix, the wash you have already applied will be dry.

• Please remember perspective when painting the sky: the clouds get smaller as they move away. Near the horizon you need to use smaller applications of paint so that the dark clouds appear to be getting further and further away.

• Also remember that the sky fades towards the horizon.

For each of the following exercises you will need 640gsm (300lb) watercolour paper with a rough surface in quarter-imperial size (381 x 280mm/15 x 11in).

A WARM SUMMER SKY

AN EARLY MORNING SKY

A THUNDERY SKY

A SHOWERY SKY

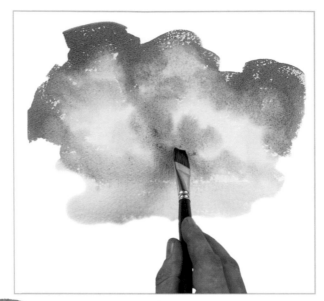

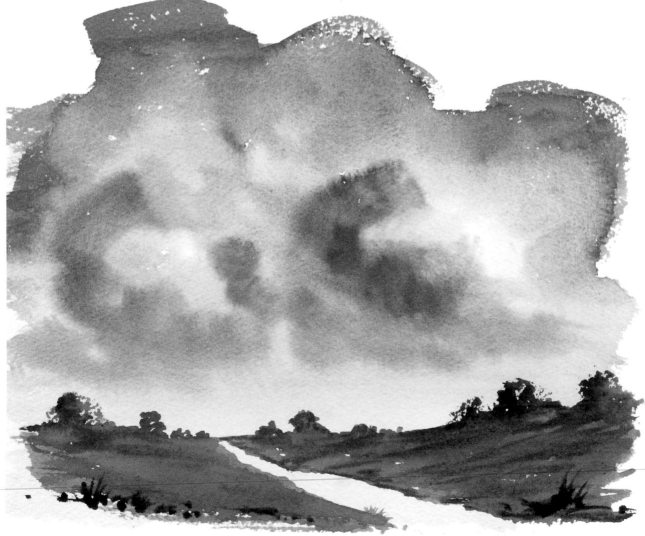

A warm summer sky

- Mix the following dilute washes using plenty of water:

RS with a touch of LR in a medium-bodied wash

FU and LR with a touch of AC to produce a purplish-blue colour

FU and a touch of LR to take the edge off the blue

- Using the 19mm (³⁄₄in) brush, dipped in plain water, wet the paper in parts, swirling the brush in circular movements. This big brush will cover the area quickly but do not soak the entire surface: be selective. The reason you partly wet the paper is to enable the colours to merge when you apply the washes. However, if you wet the paper using brushstrokes from side to side, you will not be able to get as many of those lovely shapes that you will need for clouds. Whichever way you have swirled the brush initially is the way the wash will bleed into the paper.
- First apply the wash of RS and LR using similar swirling brushstrokes to form the sunlit clouds. Apply the colour towards the top of the warm clouds; if there is any sunlight coming into the picture, this is where it will be catching the clouds. Add a few horizontal strokes towards the bottom of the sky where it nears the horizon.
- Clean the brush by dipping it in water, then return it to the wash and fade the colour towards the bottom of the sky.

TIP
- **Study the sky all the time to see what different effects and colours can be found in nature.**

- While this wash is still wet, brush on the mixture of FU and LR with a touch of AC in a mid-bodied mix, merging it in with the first wash. Apply the wash in almost semi-circular movements to the underside of the clouds and the left-hand side because if the sun is shining from the top right-hand side of the painting, the shadows will be on the bottom and left-hand side. The two washes should continue to merge as the second mix is put on.
- The mixture of FU and LR will produce the blue colour for the sky. Brush this on, cutting around the cloud shapes, and come down through the centre to give definition to the clouds themselves.

- Now wash out the brush, slightly wet it again using just water, and blend in the sky and cloud washes that have already been applied.
- While this is drying, remove the excess wash from the brush by squeezing it between your fingers and thumb, then start to soften the clouds and merge them together. Do not overwork this process – just let things all bleed together nicely. Sometimes it is better to leave well alone and let the colours work together on their own: they will pull and push against each other. Keep an eye on the process and try to control it, moulding it into the shape you require. For example, if you need to darken any of the shadows in the clouds, add a slightly thicker mixture of FU and LR and bleed this into the wash while it is still wet. When the wash starts to dry, it is time to leave it alone.

An early morning sky

This sky is perfect for a spring or autumn morning, when there tends to be plenty of weak, watery colours and lots of pale blues. At sunrise, the colours of the sky become warm, moving down from the higher reaches towards the horizon.

● Mix the following dilute washes using plenty of water:

CB and water with a touch of AC

RS with LR and AC

RS and water

● Apply the mixture of CB and AC with a 19mm (¾in) brush in the same way you would apply a graduated wash (see page 47). Brush from left to right, using two or three horizontal brushstrokes to cover no more than 20mm (¾in) of the paper at a time.

● Return to the water, thin down the mix slightly and continue with the process.
● Now merge into this wash the second mixture of RS with LR and AC, and keep on painting downwards with a series of horizontal strokes, covering less than 2.5cm (1in) of the paper with each stroke.
● Return to the water again and apply the mixture of RS and water and continue to blend this with the previous wash. Brush right down towards the horizon, adding more water as you reach the bottom of the sky area. When you reach the bottom of the paper, you might have a well of water sitting along the edge. Squeeze the moisture out of your brush with your fingers and thumb and pull the brush along the leading

edge to mop up the excess water. While this is drying, you will need to put in the clouds.
● Mix up a wash of:

FU with LR and a touch of AC in a mid-bodied mix

slightly thicker than the previous washes. Feed this into the drying wash with a very light touch. You will get a certain amount of diffusing around the edges, which gives the effect of fleecy clouds. Shape the clouds and be careful not to make them all the same size.
● It is very important that you judge carefully when to add this wash: put in too soon, when the first wash is too wet, and it will bleed too far; apply it too late and it will not bleed at all.
● Allow to dry and then put in some foreground interest to give scale and perspective. Make the foreground dark against this light sky. The lake is simply the underlying sky wash, but creates the impression of mirroring the sky above.

TIP
● The sky is nearly always going to be the biggest part of any landscape painting. It can also be the most intimidating because there is a lot of area to cover very quickly. As with any painting technique, practice makes perfect. Use a watercolour pad containing paper with a not surface or a rough grain: 355 x 280mm (14 x 11in), and just paint page after page of different kinds of sky.

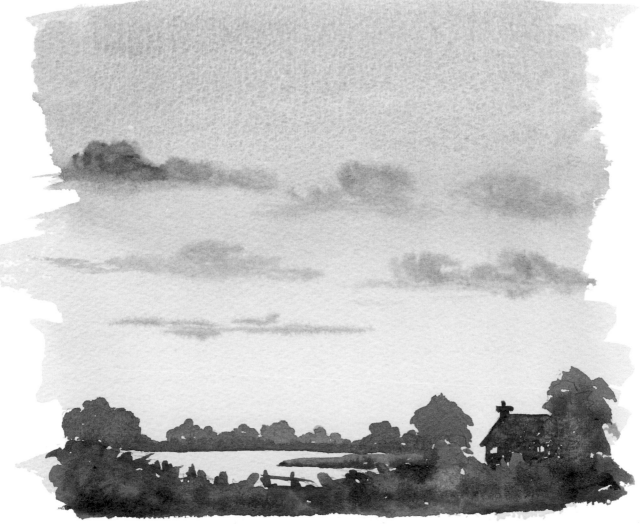

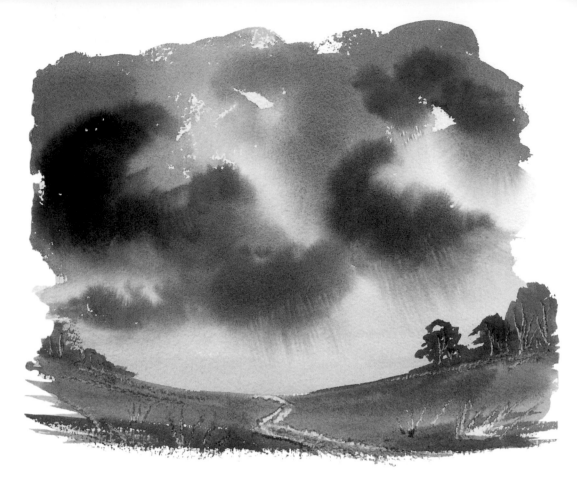

A thundery sky

- Mix the following dilute washes using plenty of water:

RS and water

AC and FU to create a pinkish-purple shade

FU with a touch of LR

- Mix the following washes in thicker mixtures:

FU and NT

FU and LR

- Start by partly wetting the paper with a 19mm (¾in) brush dipped in clean water, using swirling strokes. Feed in the wash of RS, which will bleed into the water.
- Quickly apply the wash of AC and FU to give warmth to the sky and let it merge into the previous wash. Then, with the mixture of FU and LR, put in some of the cloud shadows, shaping the clouds as you go. Remember that there is perspective in the sky, so the clouds will get smaller as they recede into the distance. Allow to dry – but not completely.
- When this wash is about mid-way through the drying process, bleed the FU and NT into the left-hand side to produce the large, dark clouds. Then add the thicker mixture of the FU and LR to give the warm brown-grey clouds. Pull the brush down at an angle of 45 degrees from the bottom of the clouds to the foreground to create a raining effect. Finally, add foreground effects to give scale and perspective.

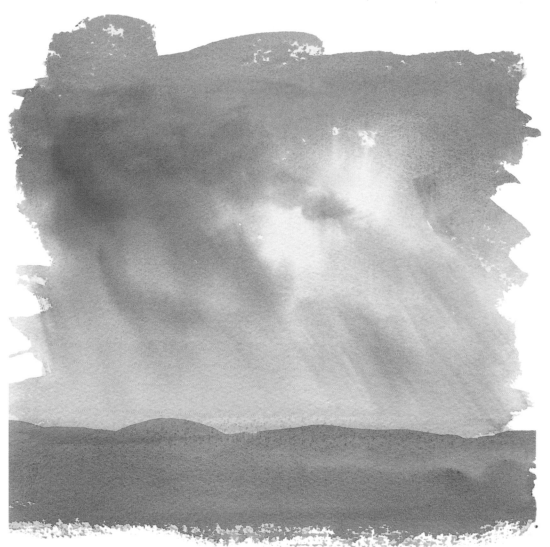

A showery sky

This is a very simple sky to produce, yet nonetheless effective. It creates an ideal impression of a spring shower.

● Mix the following dilute washes using plenty of water:

CB with a touch of AC and FU

NT and water in a mid-bodied mix

● Start the exercise by partly wetting the paper with clean water in the lightest part of the sky and along the horizon. Use horizontal strokes.

● Feed the CB, AC and FU wash into the water from the top of the paper using swirling strokes. Pull it down in diagonal strokes towards the bottom right-hand corner. Be careful not to cover all the light areas of the sky because you will need some light-wash areas to shine through, suggesting sunshine.

● While this is drying, apply the mixture of NT and water and allow it to merge into the wash already applied to give some darkness within the sky.

● Allow to dry completely and add foreground to tie it all together.

LANDSCAPES

You will encounter many kinds of landscape on your journey through watercolour painting, and they will change as regularly as the seasons.

Here are four examples of what you can expect to find, and some guidelines to help you paint them. By doing these four you will soon build up a range of techniques that will be invaluable to your watercolour painting. I suggest you sketch each of the paintings as near as possible to the original scenes.

Spend as much time as you can painting scenes like those shown here. Attend to small details at first and resist the temptation to paint the biggest landscape you can find.

When you have sky as part of your painting, you can prepare the washes for it before you begin. This will save you time as you need to paint skies quickly. For other parts of the painting, you must prepare washes immediately before you need them in order to decide the intensity of colour for each wash and to avoid the wash drying out.

> **TIP**
> • It is a good idea to leave some of the white paper exposed to give the effect of rocks and stones reflecting the light on the mountain side.

Mountains

Here is a very simple subject featuring four mountains at various distances from the foreground. If you look at the mountain furthest away, you will see that it has been sketched very loosely and freely. In the foreground there is a pathway leading the eye into the central area between the hills. There is also texture and colour in the foreground. When painting the mountains, always brush downwards in the direction of the fall.

Materials

640gsm (300lb) watercolour paper with a rough surface

19mm (¾in) Flat Sceptre Gold brush
No.8 Round Sceptre Gold brush
No.5 Cirrus Sable brush

FU and LR in a dilute mix

• Apply this pale mix to the furthest mountain using the No.8 brush. Aerial perspective (see page 36) will come into play, and there will be many atmospheric changes in the light, so little detail can be seen in this mountain.

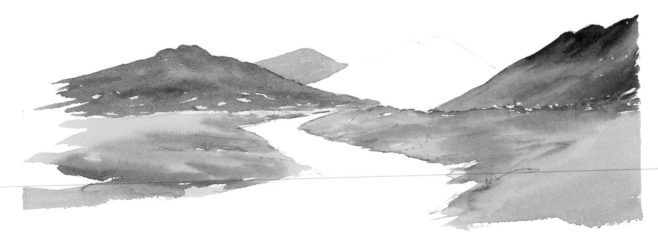

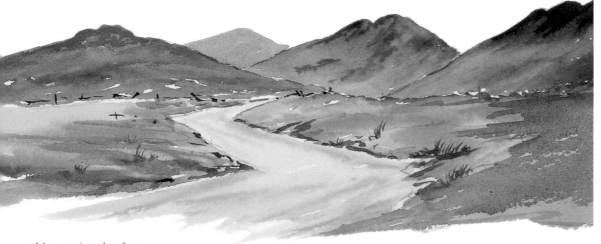

● Now paint the front mountain on the right-hand side. This is brushed in with:

FU and LR in a full-bodied mix

to give the darkness at the top. Put this on with the No.8 brush and pull down in the direction that the mountain falls. Into this bleed:

LR and water in a full-bodied wash

continuing the direction of the fall to create pale areas.
● While this LR wash is still wet, mix up:

WY and WB in a mid-bodied wash with a touch of LR

Brush this wash in to meet the foreground landscape at the bottom, and leave a jagged edge. This will blend and merge into the washes that have already been applied.
● While this wash is drying, return to the mix of FU and LR and use the No.8 brush to pull down a few strokes through the mountain. This gives texture and shadows on the surface itself. Allow to dry.
● Now attend to the mountain on the left-hand

side. Create a pale blue-grey tone using the wash of FU and LR and brush it into the mountaintop, pulling downwards to left and right, and then come straight down the centre. Bring this wash about a third of the way down from the top.
● Then apply a wash of:

WY, WB and LR in a light green shade

to fill in the mountain. Into this, feed LR on its own to create the effect of red heather across the lower reaches. Allow to dry completely.
● Now paint the middle mountain on the right. Again, apply a wash of FU and LR in a mid-bodied mixture, pulling down to the left and right. Cover a third of the mountain from the top.
● Add the light green mixture of WY, WB and LR and merge this with the first wash while it is still wet. Pull down on either side to block in the whole mountain area.
● While this is drying, mix a thicker wash of:

FU and LR

to paint in some of the rocks and shadows visible on the mountain. As you can see, these are going in the direction of the fall. It is very important that you get these right because they give character and shape to the contours of the mountain itself.
● The left-hand mountain should, by now, be completely dry, so brush in texture on the mountaintop. Use the mixture of FU and LR for this, then return to the light green wash you used before and add textured areas to the mountain itself.
● When everything is dry, begin to shape the foreground with the No.8 brush. Mix:

WY and WB in a dilute wash in a very pale green shade

and start on the left-hand side of the path from the back and work towards the front by brushing in horizontal strokes from left to right, following the contours of the land.

While this is still wet, feed in some:

LR, FU and WY

at various places throughout the foreground area to give texture and variation in tone and colour. Allow to dry.

- Repeat the same process on the right-hand side of the path. Apply texture and shadows to selected foreground areas. Allow to dry.
- When the painting is completely dry, mix up a wash of:

RS and water

and paint in the path, pulling the brush from the furthest point to the front of the paper. This will give direction to the path.

FU and AC

- With this mixture, you can add a couple of dark shadow lines into the drying wash. Squeeze the brush between your fingers and thumb to remove the excess moisture, and blend the colours together, pulling in the direction of the path so that everything follows that line. Blend this through and it will diffuse into the original wash.
- Finishing touches can be added with the No.5 brush to paint in fences, posts and blades of grass, but make sure that the grass areas are completely dry before you start. Add a few dark lines along the edge of the path to show the shadows created by stones and overhanging grass.

Coastal scene

This scene can be sketched in very quickly and it does not need an excessive amount of detail at this stage. It is nicely composed, with the cottage and trees on the left-hand side, most of the water to the right-hand side and the beach area in the foreground.

Materials

640gsm (300lb) watercolour paper with a rough surface

HB pencil

19mm (¾in) Flat Sceptre Gold brush
No.8 Round Sceptre Gold brush
No.5 Cirrus Sable brush
No.2 Cirrus Rigger brush

- Sketch the scene lightly in pencil, then, when you're happy with the composition, darken the pencil lines.

FU and LR

- Start with this wash and the No.8 brush for the mountain in the background behind the house. Because it is in the distance the colours will be diffused, showing little detail.

- While you are waiting for this to dry, paint in the beach colour using a combination of:

RS and water

Brush over the whole stretch of the beach with the 19mm (¾in) brush.

- Along the length of the water's edge, feed in a mix of:

FU and LR

to give the effect of wet sand, indicating where the waves have come up over the beach.

- It is very important when painting a coastal scene to make it look as if the water comes up over the land. The only way to get this effect is to give a slight hint of a falling beach, which is achieved by making diagonal brushstrokes.
- As you move towards the front part of the beach, flatten out the strokes because the beach is sloping away from you down to the water.
- When this area is completed, put in the tree to the left of the cottage. Use the No.8 brush, on its side and a combination of:

WY, WB and LR

Drag the brush over the surface of the paper, holding it parallel to give the broken outline of the tree.

• Then, with the point of the No.8 brush, paint in the conifer behind the building. Turn the brush on its side once more and paint in the tree to the right-hand side of the cottage, brushing lightly across the paper to give the general shape (see Tips, page 114). Add the trees and foliage beyond the cottage to the right, using the No.8 brush on its side. Indicate some of the darker foliage.

• Now concentrate on the grass areas in front of the cottage.

WY, WB and LR in a very pale green wash

Use the No.8 brush to paint in this stretch of grass quickly. Start at the back and use horizontal strokes to brush in the area right up to the broken fence that you can see in the middle distance. Leave a space for the pathway. While this is still wet, feed a darker mix of WY, WB and LR into this area to show texture and a variation of colours within the shrubbery and foliage.

• When this stretch has dried, mix up:

RS and LR with a touch of FU

Use this wash to slightly darken the colour of the foliage, and paint in some of the rocks and stones.

• You can now brush in the broad area of the foreground to show the grass expanse in front of the broken-down fence. Use a mixture of:

WY, WB and LR in a pale green wash

Feed a wash of LR through this mixture to give depth and tone, and meld in a darker shade of green, adding more WB to the mix for texture and definition.

• As this all dries, turn towards the sea.

FU and LR in a dilute mix

Apply this wash with the No.8 brush. Start at the horizon, making sure this line is level because water always appears to lie level at that distance, and brush across in horizontal strokes. Work forwards with this wash, leaving some white areas within the seascape to show that there are crests on the waves. As you progress towards the front, curve the brushstrokes in the direction of the waves as they would come into the bay to crash on to the beach. Leave more white stretches within the water area to denote the white frothy tops of the waves.

• When this is completely dry, put on a secondary wash of the same colour in selected places to give the two-toned water effect. Then feed in a darker shade of the wash to create the shadows in front of the wave edge and along the sand.

Now use a mixture of:

BS and NT

Introduce the seaweed effect on the beach with this wash. Use the No.5 brush and the same colours to paint in the ragged fence.

Block in the thatched roof of the cottage with a wash of:

RS and WY

Highlight the shadow on the gable end and under the eaves with:

FU and LR in a very dilute mix

This wash can also be used in a darker mix to paint in the windows and add the tools and equipment that appear to be leaning against the side of the cottage. Use the No.2 brush to paint this more delicate detail.

Finally, put in the boat to give a touch of scale.

WB and LR in a very dilute mix

RS and NT

The hull is produced with a mixture of WB and LR; the sails and pennant are created with a dilute mix of LR with a touch of FU in a magenta-cum-pink wash, and the mast with RS and NT.

> **TIP**
> • Remember that water is always flat, so the land falls towards it and continues underneath it.

Snow scene

This is a very cool, wintry scene, but even though it gives the impression of a freezing day, the picture still contains warmth – in the sky and on the snow.

Much of the snow is produced by the white of the paper, but it can be warmed up in places with a mixture of RS and AC.

Materials

640gsm (300lb) watercolour paper with a rough surface

HB pencil

19mm (¾in) Flat Sceptre Gold brush
No.8 Round Sceptre Gold brush
No.5 Cirrus Sable brush
No.2 Cirrus Rigger brush

Penknife

Make a sketch of the scene. Start by putting in the horizon line and then indicate precisely where the trees on the right-hand side in the foreground should be positioned.

Mix up the following washes:

FU with a touch of LR

FU with more LR

LR and RS in a dilute mix

Partly wet the sky area using the 19mm (¾in) brush and plenty of water.

Apply the wash of FU with a touch of LR in a dilute mix, pulling across the paper from left to right in a horizontal stroke. You will need to use only two or three strokes of the large brush for the effect you require.

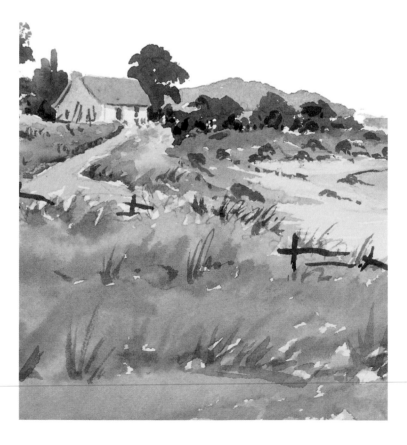

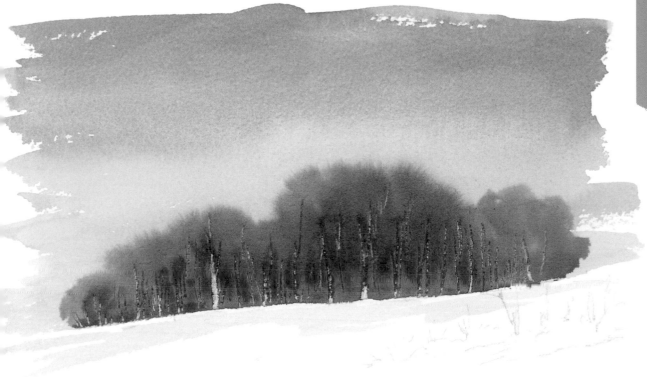

• Into this wash feed the mixture of FU with more LR, once again pulling across the paper with two or three horizontal strokes as you work downwards.

• Add the wash of LR and RS in a dilute mix, pulling across from left to right in the same process, but this time continue down to the snow-line on the horizon.

• You will need to work quickly while the wash is wet. Bleed in a thicker mixture of FU and LR with the No.8 brush and allow it to climb up and meld into the drying wash. You can see from the picture that this will explode into the drying wash to give a soft effect at the tops of the trees. As this dries, bleed in a thicker mixture of the same wash to give darkness within the trees.

• As the wash continues to dry, push the side of the penknife blade against the paper and move it slowly upwards from the base of the tree-line on the horizon to scratch back some of the damp wash and thus create a series of tree trunks and branches. This will give the impression of trees growing thickly within this forested area. You can put in as many trees as you like to give impact. Allow to dry.

• Now turn your attention to the shadows on the snow in the foreground. Mix:

FU and LR with a touch of AC in a very dilute wash

and brush on the mix.

TIPS
• **Timing is everything when working with bleeding washes. Keep a piece of rough watercolour paper to hand and test drying times before you start applying the wash to the painting.**
• **If the scratching-back technique with a penknife is attempted while the mix is too wet, the wash will bleed back into the scratched areas. If it is attempted when too dry, the wash will not scratch back at all. Choose your time carefully.**

- Then add:

AC and RS in a dilute wash

to highlight the warm areas in the snow. Let this dry completely before applying the shadows in the foreground and along the side of the path. Indicate precisely where the path runs by using a darker, thicker mixture of FU and LR.

- It is the white of the paper shining through the dilute mix that gives the snow a glowing effect. But you must have balance between light and dark, shadow and sunlight to give the snow scene impact.

- Add the green tufts of grass that are emerging through the snow in the foreground using the No.5 brush and a fusion of:

WY and WB with a touch of LR

This breaks up the expanse of snow by adding a little texture.

- The trees in the foreground should be painted with the No.2 brush and a mixture of:

BS and NT

The foliage can be added with a lighter, more dilute mixture of the same wash. Use the darker version to paint in the broken fence and posts.

Woodland scene

Several types of trees, shrubs and foliage feature in this scene, and different techniques are used to create them.

Materials

640gsm (300lb) watercolour paper with a rough surface

HB pencil

19mm (³⁄₄in) Flat Sceptre Gold brush
No.8 Round Sceptre Gold brush
No.5 Cirrus Sable brush
No.2 Cirrus Rigger brush

• Start by making a sketch of the scene. It should be very simple, indicating the pathway that meanders into the distance, the fall of the banks to give a three-dimensional effect and the position of the trees.
• When you begin painting, you must start with the blueing conifers in the far distance, produced through a simple mixture of:

FU and LR in a very pale, dilute wash

Using the No.8 brush, start at the top of the trees and pull downwards, letting the brush dance around to give a jagged effect at the tops. Allow to dry.
• Now concentrate on the left-hand conifers, starting with those nearest the middle of the picture. Apply a wash of:

FU and LR in a full-bodied mix

and use exactly the same technique as above, but this time brushing in more detail. Start at the top with one stroke and then flick from right to left and left to right, down and in towards the centre. Block in three of these trees in the sequence. Then, on one side, bleed in a fusion of:

FU and LR with a touch of WY

to give darkness and show that there are different densities within the foliage. This also helps to give a three-dimensional effect to each tree.

• Finish painting the conifers, using the same technique with a mixture of:

WY, FU and a touch of LR

More definite colour appears in the trees as they become more distinctive.
• Bleed a darker mixture of FU and LR into one side of the trees to emphasize the shadows within the foliage and give the three-dimensional effect once more. Vary the colour and lighten the green as the trees get closer to the foreground.
• Move across the pathway and attend to the larger of the trees on the right-hand side. Mix up a wash of:

WY and WB in a mid-bodied mix

to create a very pale green and use the No.8 brush to simply dot in the colour, stabbing it

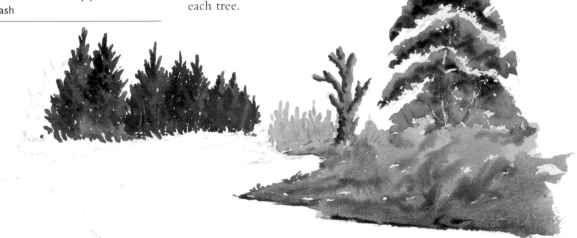

on to the paper to give the effect of ivy rising up the tree trunk and across some of the major branches. Apply this technique only half-way up the tree, then introduce the shadowed side with a combination of:

FU, WY and LR

feeding it into the drying wash that is already on the tree. It will bleed in and spread about a third of the way across the trunk and branches.

• Use the No.8 brush on its side to apply the WY and WB wash. Drag it across the paper, moving in a downward direction, to create a coarse edge at the top of the foliage: the rough paper claws the paint from the hairs of the brush. Work very quickly in a semi-circular direction to put in the three arched areas of foliage.

• While these are still wet, bleed a mixture of WY, WB and LR into the underside of them to give the mid-green effect.

• As the wash continues to dry, feed the third mixture of FU and LR into the underside of the foliage areas so that shadows are created in these lower regions.

• Let these washes dry completely before using the No.2 brush to paint in the trunk and some of the major branches with a mixture of:

BS and NT

• Use the same colour to brush in the branches emerging from the ivy-covered area of the tree towards the centre. Move upwards with the brush, flicking up and away to add twig effects at the ends of the branches. Darken one side of the tree to indicate shadows by using a thicker mixture of the same two colours.

• Apply foliage with a pale and wintry-looking wash of WY and WB in a very dilute mix; it is really just a stain on the paper.

• The smaller tree on the right-hand side is produced using three washes:

WY and WB in a mid-bodied mix

WY, WB and LR to create a mid-tone green in a mid-bodied mix

FU and LR in a mid-bodied mix

• Now introduce the washes for the bank, using an assortment of green mixes in varying tones:

WY, WB and LR in a mid-bodied wash

CB, WY and LR in a mid-bodied wash

BS and WB in a full-bodied wash

Use plenty of water to lighten each mix as necessary. Pull the brushstrokes forward in the direction that the banks are falling, and darken these areas towards the bottom using FU and LR to brush in shadows and shading.

• When the wash has dried, put on some figuring with the No.5 brush and add the tufts of grass in the foreground. Allow to dry.

• Now you can attend to the path using a mixture of:

RS and AC in a very dilute mix

Brush in from the back in the direction of the path. Bleed in a mixture of:

FU and AC

and blend the washes together to give texture. Allow to dry.

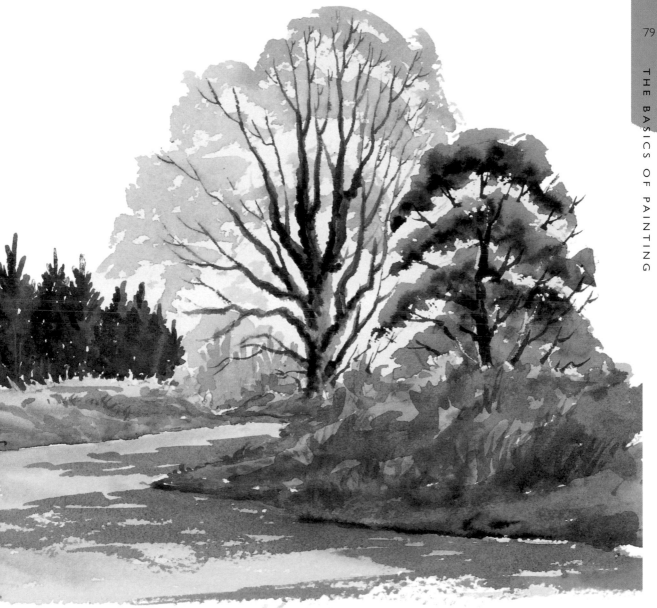

● Finally, add shadows to the pathway, using a combination of FU and LR. The shadows cast by the trees fall across the banks and pathway, giving character and depth to the whole scene.

TIPS
• Remember to show the effects of aerial perspective as the trees recede into the distance.
• Use directional brushstrokes to indicate the form of the landscape.
• When painting shadows on the ground, always follow the contours of the land.

Five paintings in detail

STEP-BY-STEP GUIDES

This chapter breaks down five of the paintings featured in the third series of *Awash with Colour* and shows you exactly how they were created. You are taken through a step-by-step guide of their development from the initial sketch to the finished product, learning how to paint them for yourself.

Each painting has a sketch and four stages to its make-up. Rather than give a stroke-by-stroke description of my original painting, I explain how to work through all the stages to achieve the best results.

Each painting uses many of the techniques and exercises featured earlier in the book, so refer back to them whenever necessary.

Each project lists what materials to use, explains how to mix and apply the colours and how to create many of the effects in the original.

When practising, try not to copy the paintings exactly because this will stifle the development of your own original style.

You will inevitably make mistakes when copying work by other artists, but these could well be to your advantage. You might discover a technique that is unique to you and which helps to build your style. Such happy accidents help to create your own identity as a painter.

TIPS

- Read over the description of each illustration two or three times before you start to paint to avoid making mistakes.
- Practise first on a rough piece of paper to make sure you have familiarized yourself enough with the directions. Do this with each stage of the picture's development.

THE COTTAGE
AT TULLYMORE FOREST PARK

I met Shauna Lowry in the heart of Tullymore Forest Park, which lies between Castle Wellan and Newcastle in County Down. Shauna loves horses, so I wasn't surprised to find her enjoying a day's riding in this wonderful part of Ireland, which provided another painting location for *Awash with Colour*.

It is said that you should never work with children or animals. Well, Shauna must be an exception to that rule, especially where animals are concerned. She spends much of her professional life working with them on such television shows as *Animal Hospital* and *Battersea Dogs Home*, and she has established herself as one of the bubbliest presenters on television.

We managed to track her down on one of her rare days off and invited her along to try her hand at watercolour painting. We got on famously. We chose this charming cottage at Tullymore Forest Park for our subject, and it was a fantastic location for painting. The darkness of the trees behind the cottage made it stand out and come to life, while the rays of the low winter sun made the gable end wall glow. Dark branches on the bare winter trees cut across the wall, casting long shadows that gave great atmosphere and feeling to the composition. The scene had immense character. The pathway in the foreground leads the eye to the focal point of the painting before disappearing into the distance.

When we first met, Shauna brought along a picture she had painted when she was five years old and attending Wallace High School. It was a colourful picture of a chimpanzee called Chimpy and it was an interesting painting for one so young: full of colour and texture. I asked Shauna how she had created the marvellous texture.

'That was easy,' she said, 'I pulled the fluff out of my blazer pockets and stuck it on to the picture.'

Shauna hadn't painted since her schooldays, but she took to the task and did a very good job. She certainly enjoyed mixing washes, merging the colours and bleeding them into each other. She was very impressed at how simple it was to get such an effective painting using light and shade to give it depth, and couldn't wait to rush back to London to show it to her *Animal Hospital* co-star, Rolf Harris, just to prove that she could paint as well.

Materials

640gsm (300lb) watercolour paper with a rough surface in quarter-imperial size

19mm (¾in) Flat Sceptre Gold brush
No.8 Round Sceptre Gold brush
No.5 Cirrus Sable brush
No.2 Cirrus Rigger brush

Penknife

- With the HB pencil sketch the cottage just off-centre, to the right. Work lightly to begin with to make sure that the composition is balanced and the perspective is right. When you are happy with the results, strengthen all the lines.
- Sketch in the tops of the background trees, then add the pathway in the foreground.
- Add the large tree in the foreground and your sketch should be complete.
- Finally, apply masking fluid to the tree trunks and branches and allow to dry.

STAGE 1

Mix up the following washes for the sky, using plenty of water:

FU with a small amount of LR in a mid-bodied mix

CB with a touch of AC in a mid-bodied mix

Equal amounts of FU and AC in a dilute wash

RS and a touch of LR in a dilute wash

- The sky is created by using a colour-graduated wash (see page 47). Start by applying the mixture of FU and LR using the 19mm (¾in) brush.
- Make sure that the angle of your drawing board is about 15 degrees from the horizontal. This will allow the washes to run slightly towards you as you apply them to the paper.
- Start at the top and pull the loaded brush across the paper from one side to the other. The paint will disperse on to the paper more easily if you do not apply too much pressure to the brush. Work downwards in a graduated wash.

- After a few strokes, apply the mixture of CB and AC in the same way. A few strokes later, repeat the process again with the mix of FU and AC. Next, add in the mixture of RS and LR, fading the wash out as it progresses down the paper towards the bottom of the line of trees in the background. The secret here is speed because you do not want the wash to dry. The completed wash should still be wet towards the bottom and damp towards the top as you start the next process.
- Very quickly prepare another wash of:

FU and LR in a mid-bodied mixture in a purplish-blue colour

Apply it with the 19mm (¾in) brush to paint in the rough shapes of the treetops. Pull the brush downwards and stop at the bottom line of them.
- Continue applying this same wash to the bank of trees, but be careful to cut neatly around the roof and the walls of the cottage so that you retain the shape of the building against the dark backdrop.
- As the sky wash is still damp, you will see a certain amount of merging take place where the top of the secondary wash bleeds up, diffusing with the wash above, to give a very soft top to the trees. It should spread only so far, then suddenly stop.
- While this is drying, use the same brush to feed a darker mixture of FU and LR into this wash to show that there are shadows and darkness within the trees at the back of the cottage. You will always have a different tone of shadow colour as you penetrate deeper into the forest, just as those areas where the sun is shining will be slightly lighter.

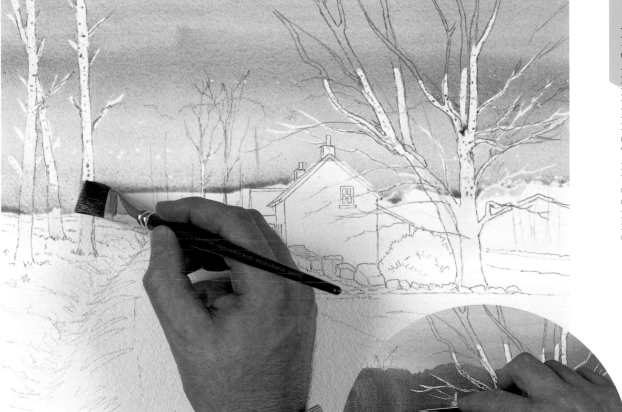

● Add:

A little WY and water in a mid-bodied mix

here and there to the wash to add a hint of light
green to the background trees. The mixture
should not be too thin, otherwise it will dilute
the FU and LR.

● While this wash is drying, use the side of the
penknife blade to scratch upwards against a few
tree trunks, creating the impression of sunlight
within the darkness.

● If you need to put in some dark tree trunks,
let the wash dry. Then, with a combination of
FU and LR, use the No.5 brush to lightly mark
in a few trunks where necessary to show that
there are trees growing within the density of
the wood.

*AT THE RIGHT STAGE OF
DRYING, NEITHER TOO WET NOR
TOO DRY, PUSH THE PENKNIFE
BLADE GENTLY UPWARDS TO
SQUEEZE THE WASH AWAY FROM
THE BRANCHES. THIS REVEALS
THE WHITE OF THE PAPER TO
CREATE THE BRANCHES.*

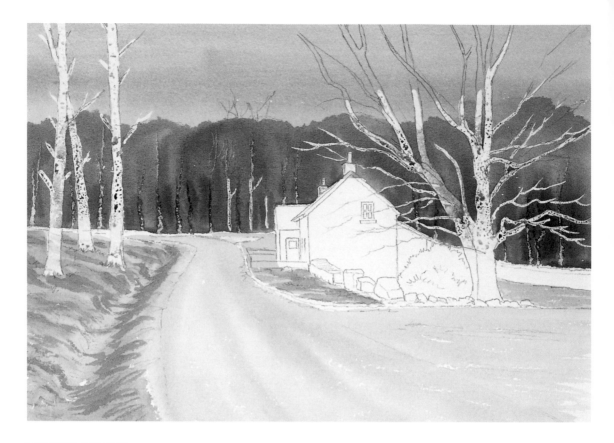

STAGE 2

- Apply:

RS and LR in a very dilute wash

to the pathway using the 19mm (¾in) brush. Start at the far end of the path and pull the brush back towards you, fanning out to right and left with each stroke until the pathway is covered.

- Quickly mix together a secondary wash of:

FU and AC in a mid-bodied mixture

With the No.8 brush, start at the back of the path and pull the brush towards you down through the centre, following the contours. Return to the far end of the path and with one brushstroke, pull down the left-hand side. Repeat the process and pull a stroke down the right-hand side. You will notice that this looks very intrusive and stands out. Take the 19mm (¾in) brush, washed and squeezed dry of excess moisture, and blend the colours together, pulling from the back to the front of the pathway. Do not overdo this

process, and you will find that the secondary colour you have put on will bleed in to make texture on the path's surface. Allow to dry.

- When the pathway is dry, brush in the green areas using the 19mm (¾in) brush and a wash of:

WY, WB and LR

Start on the left-hand side of the path with directional strokes following the lie of the bank. Then start on the right-hand side of the gully, again following the fall into the dip. Feed in a darker green, which is produced with the same three colours in a stronger mix. Brush this in and follow the lie of the bank from the left-hand side.

- Continue these directional brushstrokes into the little gully on the left-hand side to indicate its shape. You will find the directional strokes work very well.
- Add in the rest of the green areas in the same way, but remember to cut neatly around the cottage. Allow to dry.

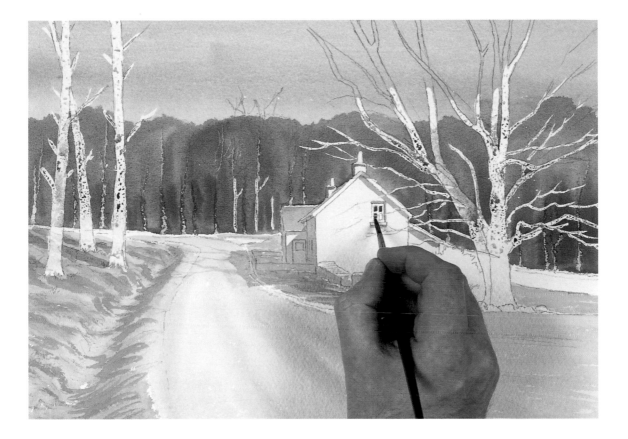

STAGE 3

• Block in the walls and chimney of the cottage using the No.8 brush and:

RS and WY in a very dilute mix

This wash should be little more than a stain.
• When dry, paint in the roof using the No.5 brush with a mixture of:

FU, LR and AC

Leave space for the green facia board around the cottage. Allow to dry.
• Now add in the shadows on the left-hand side of the cottage using :

FU and LR in a very dilute mix

You can see that the shadow of the building is cast on the pathway.
• Using the same strength mix and the No.5 brush, add in shadows under the eaves, down the side of the window and underneath the window sill, underneath the chimney and on the copings.

• Check to see that the shadow wash around the window is dry, and then paint in the window panes themselves. Make four rectangular strokes using the No.5 brush and a mixture of:

FU and LR

Use the white of the paper to form the frames.
• The green bushes and the stones at the side of the pathway are next on the agenda. Use a mixture of:

WY and WB in varying strengths

to produce the appropriate green shade.
• When all the washes are completely dry, remove the masking fluid with a kneadable putty rubber. Start at the bottom of the trees and rub upwards: the end of each piece of masking fluid will begin to peel. Use your finger and thumb to lift off the pieces until all have been removed.

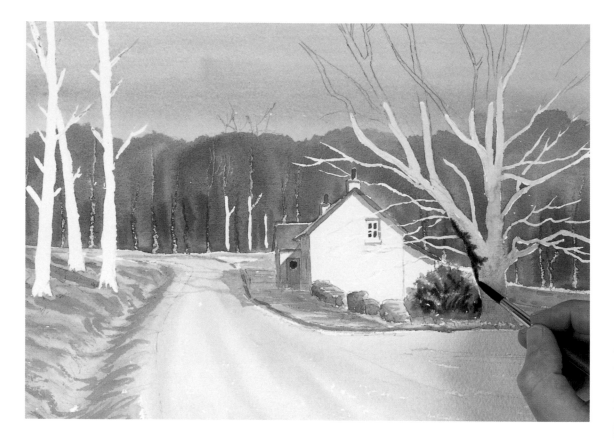

STAGE 4

● Prepare a mixture of:

RS and NT in a very dilute wash

Take the No.8 brush and pull upwards on the trunk of the tree, adding in the major branches. Make these taper towards the ends by letting the pressure off the brush. Do not try to paint in all of the branches at this stage. Venture only about half-way up the tree.

● As the wash is drying, feed a slightly thicker combination of:

BS and NT

into one side. If the original wash is at the right stage of drying, this secondary mixture will merge across about a third of the tree before stopping, to give the feeling of darkness on one side.

● Add to this a full-bodied wash of the same two colours to give you texture and roundness.

Continue with the upper half of the tree in the same way using the No.5 brush. The No.2 brush can be used for the smaller branches and twigs.

● All the branches will now be the same strength, so taper them out to form points and put in a few twigs on each extension.

● Next, paint in the branches that cover the gable end wall of the cottage. Note that even though these branches point downwards, they always flick up towards the ends. Do not put in too many as they will look overworked.

● Finally, with a mixture of:

FU and LR

use the No.2 brush to put the shadows of a few branches against the sunlit wall.

● Put in the fence and brush texture on to the ground and your painting is complete.

" I'm really happy with it. I'll have to try it on my own now… I'll be able to teach Rolf a thing or two!"

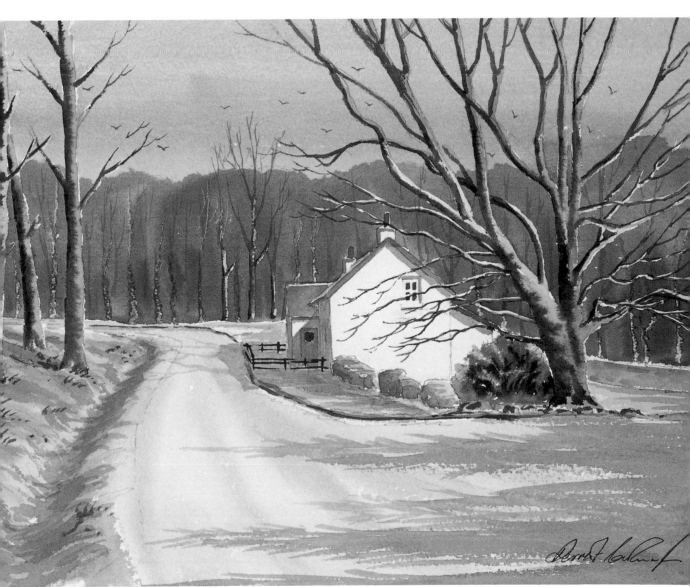

A SCENE AT MAGHARA STRAND

Brian Kennedy is an extremely gifted Irish singer/songwriter and talented musician, and he is by no means a bad artist either. He joined me for one episode of *Awash with Colour* and took to painting very easily.

Our location was Maghara Strand, about three miles from Ardara in north-west Donegal. It is one of the most beautiful places I have ever visited in my life. The area around here is teeming with potential paintings: just about everywhere you look there's a scene willing you to get it down on paper. It really is a painter's paradise.

For the television series we painted the scene looking from Maghara Strand towards Ardara when the tide was in. For the purpose of this book, I have recreated the painting with the tide out.

When it comes to painting flat landscapes or seascapes, it is very important to show distance and space. This is achieved by simplifying the background and strengthening the foreground. Yet it is important not to overdo the detail in the foreground otherwise it becomes too fussy.

Materials

640gsm (300lb) watercolour paper with a rough surface in half-imperial size
HB pencil
Penknife
19mm (³⁄₄in) Flat Sceptre Gold brush No.8 Round Sceptre Gold brush No.5 Cirrus Sable brush No.2 Cirrus Rigger brush

• With the HB pencil, sketch in the shape of the far-distant hills and the mountain on the right, adding some stone shapes in the foreground. Note that the water-line along the bottom of the mountain and hills is level. This means that the beach will be lying level too. There is very little sketching to do in this picture.

• When the sketch is complete, you can start to apply the sky. Remember to prepare all your washes for the sky beforehand as you need to paint quite quickly.

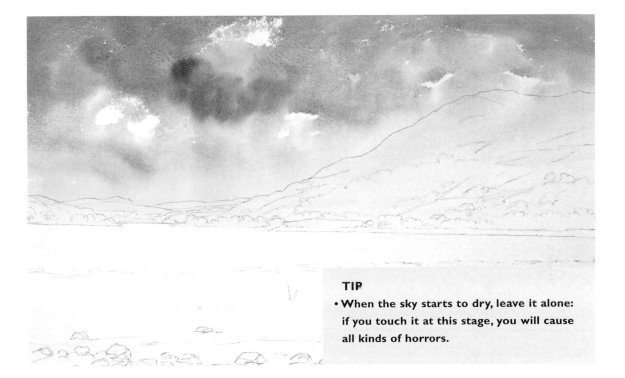

TIP
• **When the sky starts to dry, leave it alone: if you touch it at this stage, you will cause all kinds of horrors.**

STAGE 1

Mix up the following very dilute washes for the sky, using plenty of water:

RS and water

CB with a tiny amount of AC in a mid-bodied wash

FU with a touch of LR in a mid-bodied wash.

• Using the 19mm (¾in) brush, slightly wet the paper using swirling strokes across the lower reaches of the sky. Do not wet the paper at the top of the sky. Apply water sporadically about half-way up into the sky for the far-distant hills. Do not wet all the paper.

• Paint in the first mix of RS and water in a swirling movement to indicate the tops of warm clouds.

• Feed in the second mix of CB and AC to cradle the underside of some of the clouds. Fade this down towards the horizon in a graduated way so that the sky weakens towards the bottom.

• Just above the top of the RS wash, work in this same mix and give shape to the cloudtops. Leave some white spaces between the two

mixes, but blend them in other places so that you get a nice bleeding wash as you work.

• Do not be too worried about painting over the mountain at this stage because it is going to be a lot darker than the wash you are putting on for the sky.

• Apply the mid-bodied wash of FU and LR, starting at the top left-hand corner, and work down to meet the CB and AC you have just applied. Keep working from left to right, pulling down from the corner into the centre. Now move across the top and fill in most of the white spaces, pulling down from the top right-hand corner. Blend all these washes together.

• Whenever you are finishing off, be very careful not to overwork the sky. Take the excess wash off the brush, dry it between your fingers and thumb, and use it to blend the washes through, but let them do their own work.

• Now leave the sky to see how it dries out. If you feel you need to strengthen some of the areas, do so while the wash is wet. Allow the sky to dry completely.

STAGE 2

You can now concentrate on the mountain.

Mix up the following washes:

FU and LR in a mid-bodied wash to produce a dark, purplish-blue shade. This is achieved by putting in the FU first and feeding in small amounts of LR until you create the tone of purple you need.

LR and water in a mid-bodied mix

WY and WB in a mid-bodied mixture to produce a light green colour

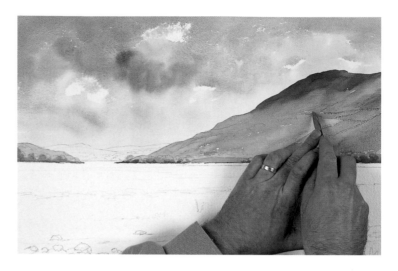

- Using the 19mm (¾in) brush and the mixture of FU and LR, start painting at the highest point of the mountain on the right-hand side. Pull down the wash in the direction of the slope.
- Then quickly feed in the LR and water mix in the same way as the FU and LR. This allows for a more subtle change between the dark FU and LR mix and the light green mix to be applied next.
- Dip straight into the light green mix – there's no need to wash the brush at any time – and pull down the slope of the mountain until it meets the beach. Continue working from left to right and pulling down as you move back to the right-hand side. Follow the lie of the land.
- When you get back to the far right-hand side, return to the FU and LR mix and very lightly feed in some shadows through the mountain using directional brushstrokes. Follow the fall of the mountain. It should be diffused, having no detail within it: simply work on following the contour of the land.
- To indicate the little walls on the hillside, use the side of the penknife blade to scratch back some of the damp wash. If attempted while the mix is too wet, the wash will bleed back into the space you have left with the blade. If attempted when the wash is too dry, it will not scratch back at all, so choose your time carefully. Scratch in just a few lines, some moving diagonally down the hill, some moving horizontally. Allow to dry.

- While you are waiting for this to dry, you can put in some of the headland on the opposite side of the bay. Leave the distant hills until the mountain is completely dry.
- When you are satisfied that this has happened, mix together FU and LR in a dilute mixture veering towards a bluish-purple. Paint in the shape of the distant hills. Feed in WY as you move towards the bottom of the hills to give a hint of the diffused green colour, but this has to be very weak.

TIP

- The direction of the mountain slope – the natural lie of the land – is very important because you must pull the brushstroke in the same way. Move the brush down, covering the top 2.5cm (1in) of the mountain, and shape the wash to left and right in the direction the mountain is falling. Continue back towards the right-hand side of the mountain. When you pull this down, leave a jagged edge to it and feed in some of the LR mix to bleed into the wash.

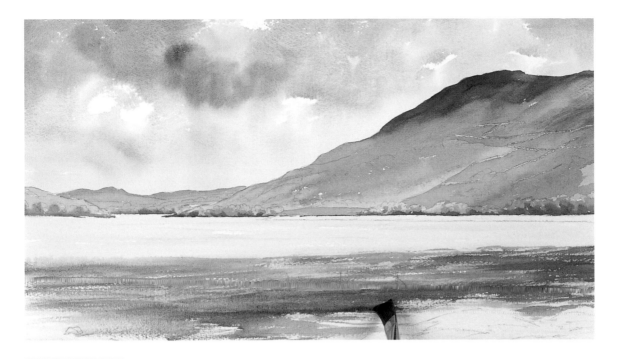

STAGE 3

Although the tide is out and the sand is exposed, there are still pools of water to be seen, so mix up the following washes:

RS with a touch of AC and plenty of water

CB with a tiny amount of AC in a dilute mix

RS and LR in a mid-bodied wash

● Using the 19mm (¾in) brush and the first mix, start at the back of the water, just below the mountain, and apply the wash very lightly, making horizontal strokes from left to right. Do not cover the headland. As you move forwards, pull the strokes from left to right and from right to left so that they are overlapping; make them broader and more bland nearer the front. Leave spaces to add in the second wash, blending it into the first to produce a light, sandy colour and the blue of the water.

● Introduce more LR into the mix of RS and LR to give a stronger, redder tone, and bleed this through so that it diffuses together. As you move towards the seaweed area, add more LR and bleed this over the whole expanse so that it merges with the other colours. The effect you should obtain is a sequence showing a light,

sunlit, sandy colour with water going across; the same colour with more water going across; then a reddish tone of the sandy colour with yet more water going across. You can see from the illustration where the water is lying on the sand.

● While the seaweed area is drying, feed in:

LR and NT

to give darker accents and texture.

● Using the mix of RS and AC in a very light wash, work on the area of stones. Feed through this a wash of:

WY and WB

from the right-hand side to give the grassy area. Into this feed a darker mixture of WY and WB with a little LR to give definition. Allow to dry.

TIP
● **Where the sand is damp, you will have reflections of the sky, made by using dilute washes of CB and AC. Experiment on test paper before applying to the painting to show the light as appropriate.**

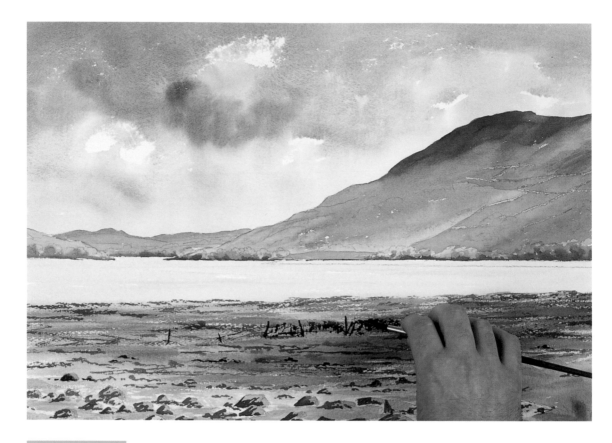

STAGE 4

Now turn your attention to applying texture to the seaweed area.

- With a mixture of:

FU, LR and a hint of NT

use a semi-dry 19mm (¾in) brush to drag the wash over the surface of the seaweed area.

- When this is dry, you can start to shape some of the stones. Notice that the side facing away from the source of light is darker. Paint in the stone shapes, one at a time, with a mixture of:

RS and BS

When dry, add the darker tones with a mix of:

LR and FU

brushing over the top of the original wash, but only on the side of the stones facing away from the light. Show a few angles in the stones and a variety of shapes. You will see from your original sketch there are stones of all shapes and sizes.

- Add the forest on the mountainside with:

WY and WB with a touch of LR in a
mid-bodied wash

Don't add too much detail as you want to give only an impression of the forest.

- For the final detail, start by putting in the little stretch of seaweed. Stick in a few oddly angled fenceposts with the No.2 brush. Then use the side of the No.8 brush with a mix of:

BS and NT

to put seaweed on the tip of the fence and drag it down to show the effect of the seaweed hanging loose. Don't overdo it.

- To complete the painting put a little figuring of grass round the front using the No.5 brush and a mix of WY and WB. Apply a few strokes of the same wash to the water's edge of the far mountain and to the hills in the far distance to indicate hedges and undergrowth.

Painting is so methodical, it makes a great deal of sense. I thought it was going to be an awful lot harder, but you've explained it very well… I love it.

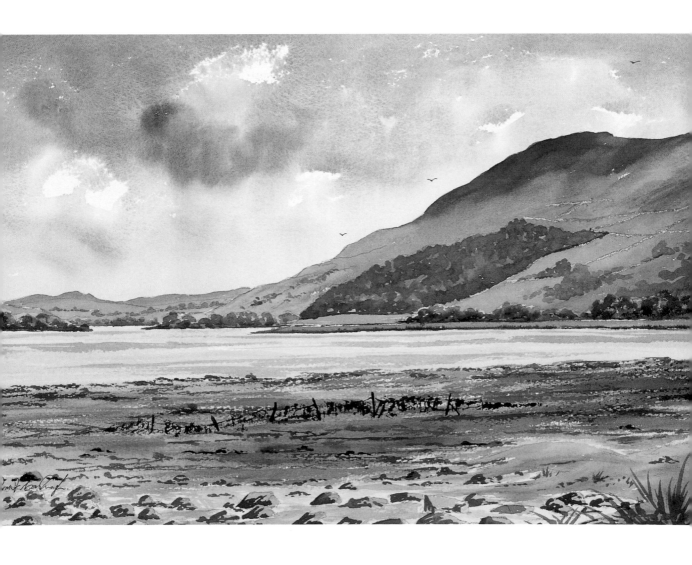

BOOKS AT NARROW WATER CASTLE

'Now let's look at the clues… A pile of old books in the corner of a library… Who lives in a house like this?' You can almost hear Loyd Grossman saying those words.

The gourmet, television pundit and star of *Through the Keyhole* was our guest when *Awash with Colour* visited Narrow Water Castle, the home of Roger Hall. Indeed, the castle has been home to the Hall family since the 1790s. In its well-stocked library a pile of books set the artist a different challenge – one of the few still-life subjects to be featured on our television series.

With this painting, as in all still lifes, you need to emphasize the subject in the foreground (the books) and slightly soften the background so that it does not take on too much prominence in the painting.

Loyd was a great sport and entered into the spirit of the show with great gusto. He wasn't bad either, and took great pride in his new-found talent.

The original still life was painted in oils, but for the purpose of this book, the treatment is in watercolour.

Materials

640gsm (300lb) watercolour paper with a not cold-pressed surface, medium grain, in quarter-imperial size. I have found through experience that for still-life painting, where there are definite edges, it is better to use a medium-grain paper.

HB pencil

19mm (¾in) Flat Sceptre Gold brush
No.8 Round Sceptre Gold brush
No.5 Cirrus Sable brush
No.2 Cirrus Rigger brush

● When building up the sketch, please remember the lessons on perspective (see pages 32–8).
● With an HB pencil, sketch in the scene, lightly marking the shapes of the books. This is where your knowledge of perspective will be tested to the full. Try to match your sketch as near as possible to the illustration.
● Start by sketching the books and then work everything else around them. Sketch lightly so that any mistakes can be easily corrected without leaving traces of the lines. When you are sure of the result, strengthen the lines. However, do not put too much emphasis on the background. There is a little bit of colour in there, provided by the magazines lying on the chaise-longue, so add these to the scene. On the table there are more magazines and a cup and saucer. The whole picture should be treated in a very bold way.

STAGE 1

• When you have completed the pencil sketch, you can start blocking in the background of the scene with the 19mm (¾in) brush.

• Paint the curtains with:

RS, LR and a touch of FU in a dilute wash

LR and NT in a dilute wash

Use the first wash for the light stripes and the second wash for the dark. You can see that there are folds and pleats within the curtains, which can be emphasized through a mixture of:

FU and LR in varying strengths

for lighter and darker shadows.

• Block in the wood panelling with FU and LR. When this is dry, apply the shadows, using the same FU and LR wash but in a mid-bodied mixture.

• Paint the chaise-longue with:

RS and AC in a very dilute mix

FU and LR in a very dilute mix

Use the first wash for the general colour of the chaise-longue and the second for the side with shadows.

• Notice how dark the shadows are on the top left-hand side of the painting and below the chaise-longue. To indicate the presence of books on the shelf use varying shades of diffused blues, reds and browns. Try to match the colours as closely as possible to what you see in the painting. Use the 19mm (¾in) brush for the broad areas and the No.8 for the detail. Allow to dry.

STAGE 2

- When the background area is completely dry, start working on the table surface with:

WY and WB in a very dilute mix with some BS

to give that greening effect. This will be achieved with a couple of applications of the wash, using it in a very dilute state at first and then feeding in a darker tone in places with the 19mm (¾in) brush.
- When painting in the table top, use vertical brushstrokes to apply the washes to give a shine to the leather surface. Then squeeze the hairs of the brush between your fingers and thumb to take out excess moisture and drag the brush across the table top in a few places in a horizontal motion. This will remove some of the wash from the paper.
- When the top is dry, paint in a wooden trim around the table with:

BS and a little NT in a mid-bodied mix

FU and LR in a mid-bodied wash

Use the second wash to add some shadows to the grooves on the table edge.
- Next concentrate on blocking in the books. The first wash on each book will establish the basic colour. I suggest you use the No.8 brush to apply these washes.

- There are eight books in the pile and one in front of the pile. Start by blocking in books one and two – leatherbound volumes at the top, using:

RS and a little BS in a mid-bodied wash

Cut neatly round the area of the pages, leaving them white, and also leave some small areas of white along the edge of the ribs on the spines of these two books.
- Skip book three and apply the same wash to the spine of book four (you do not need to reproduce the illustration on the spine). Skipping books is very important so as not to have bleed back between washes. Skip book five and mix a blue-grey wash of:

FU, CB and a touch of AC in a mid-bodied wash

Apply this wash to the protruding corners of book six and book three, and to the cover of book four under the sleeve of book three, cutting round the white for the pages. Now move to book seven and using:

RS, a little WY and LR in a dilute wash

apply the yellow colour for this cover.
- While you are waiting for this wash to dry, turn your attention to the magazines. Using a number of your previous mixes, block in the magazines, trying to match them as closely as possible to what you see in the painting.
- Then mix up a red wash for book eight using:

AC, LR and WY in a dilute wash

Also apply this wash to the hard cover (not the jacket) of book four, cutting round the page. To the book in the foreground, apply a mixture of:

CB and FU in a dilute wash

Continue to block in the remaining books, using washes to match the illustration. Although the pages look white, they should be blocked in with a creamy-coloured mixture of:

RS and water in a very dilute wash

Also block in the cup and saucer. At the end of this stage, the books are taking shape but are still devoid of light and shade. Allow to dry.

STAGE 3

• You can now paint in the shadowed areas to give the picture definition and depth. Prepare a wash of:

FU and LR

• Work down the pile of books from top to bottom. Apply the shadow wash with the No.8 brush to any area that is facing away from the source of light on the right. Notice that there are also shadows between some of the books along the sunlit side and on the spines of the leatherbound volumes. By applying the shadow wash on top of the original wash the colour of the shadow changes because the underlying wash shows through.

• Also add shadow along the edge of the magazines, inside the tea cup and saucer and on the table top itself.

• When the shadow on the books is dry, apply a secondary shadow wash to some areas, using the No.5 brush. Darken the edges of the

book covers on the side facing away from the source of light, and show the shadow cast by the overhang of book seven on the sunlit side. Apply a second application of the wash to strengthen the shadows on the spines of the leatherbound books.

TIP
• **When painting the table surface and background, you will have to cut neatly around any light areas – the cup, the magazines, the books, the flowers – because you must retain the white of the paper here. Work with the brush techniques learned earlier in the book (pages 40–5) to get as close to these edges as possible.**

STAGE 4

- Now for the finishing details. With a combination of:

RS, LR, a little NT and lots of water in a mid-bodied mix

you will be able to create an aged effect to the leatherbound volumes. Add this to the areas required.

- To show texture to the book in the foreground, apply a secondary wash of:

FU and CB in a mid-bodied wash

to the top, using the No.8 brush. Pull the brush across the top of the book from right to left.

- You do not need to put in too much detail – it is important that you do not overwork the picture.
- Moving down, you will see reflections on the table from the red and blue books, but both are very vague. To capture this effect, dilute the colour washes you used originally to paint in these books:

LR, AC with a touch of WY in a dilute wash

FU and CB in a very dilute wash

and apply with the 19mm (¾in) brush. Allow to dry.

- To finish off, you need to add a little detail to the books. The top two volumes have green and red labels, which can be created with a mixture of:

WY and WB

brushed over the wash that has already been applied to give a dark green effect and:

AC and LR

for the red.

- Several books show writing, but I suggest you omit this for simplicity. Sometimes less is more.
- Tidy the picture up, but don't overwork it. Remember, it is a general impression that you are after.

❝I've always been inspired by painting, yet it's something that has always frightened me.❞

BETTY FAIRCLOUGH'S FARM COTTAGE

There is very little that I would want to change in this composition. Betty Fairclough's delightful cottage proved an ideal composition, crying out to be painted. This was the special treat I had in store for my guest, Mary Black, the talented and beautiful Irish folk singer, when she appeared in the very first programme in the third series of *Awash with Colour*.

I came across the cottage one spring evening while I was driving along the road from Clogher Head and Annagassan in County Louth. It was late and I was despairing that I would ever find a suitable painting location for the new series. Then, almost by chance, I turned the corner and came across this idyll at a road junction. The scene had everything to inspire any artist. I wanted to paint it immediately, to capture its perfection then and there.

The sun was in the west, lighting up the gable end wall. The front of the cottage was in complete darkness and shadows were cast across the roadway. The tree next to the cottage was bare of leaves, standing stark against the light sky. The stone walls of the out-buildings looked fabulous, semi-lit by a low sun, with the wall in the foreground casting a shadow across the grass and path. It was bright and glowing. The whole scene was framed beautifully by the foliage on the left-hand side and the bush growing out of the wall on the right.

Immediately I determined that this was going to be a painting location. I could see it would give a fantastic feeling of light and shade. It had everything going for it and would look wonderful on television.

You can see the three-dimensional look that the sunlight and shadows give to the cottage. As the stonework is in shadow, it appears blue; where it is facing the source of light, it appears warm and orange-looking. The trees break up the painting; the fact that there are no leaves on them emphasizes their character. The tree to the right is casting a shadow across the stonework, which helps to add interest. The road leads the eye directly into the focal point and it makes you wonder what is just around the corner.

Mary Black was a charming guest. She took great delight in being able to paint the scene as well as she did. Mary had no background in painting – in fact, had rarely painted since leaving school – but she was amazed to see how uncomplicated the exercises were. She told me that when the painting was broken down into such simple terms, she found it quite easy to follow and get the hang of what she was doing. She discovered that the sketch was a great help because the plan was then in place to work from, and she also learnt that she had to underpaint all the buildings.

It was Easter Monday, a bitter cold day, that we'd chosen to do our painting. When we arrived in the morning to set up the shoot, there was actually snow on the ground. By lunchtime, however, the snow had cleared and we were filming. Although there was a biting east wind blowing across from the sea, we managed to get through the day and had time for a bit of fun as well.

Mary is left-handed, and with her standing on the left-hand side of the easel and me on the right it was often difficult for me to get control of the brush when she was going wrong. Nonetheless, she was so good that I actually suggested to her that we should form a partnership: she could paint the left-hand side of the painting, I could cover the right. We even devised a special giant-sized Aran sweater containing two holes for our heads so that Mary could be the left arm and I could be the right.

I think Mary really enjoyed the day. She took her painting away and it is now framed, hanging on her wall.

TIPS

When dealing with a complex scene, keep the sky simple.

- **When there is a tree featuring prominently in the scene, as there is on the left of this painting, position the tree against a light-coloured sky to make it stand out against the backdrop.**

Materials

640gsm (300lb) watercolour paper with a rough surface in half-imperial size

HB pencil

Masking fluid

Putty rubber

19mm (¾in) Flat Sceptre Gold brush
No.8 Round Sceptre Gold brush
No.5 Cirrus Sable brush
No.2 Cirrus Rigger brush

- Start by sketching the scene with the HB pencil. This is soft and easy to use on the rough paper, and does not give too dark a line.
- Draw in the outline of the cottage, gauging the size that you want the building to be, and develop your sketch from there. Lean very lightly on the pencil so that you do not create a dark sketch. The other advantage of drawing lightly is that if you do have to use the eraser, there will not be too much to rub out. Darken the lines whenever you are sure that you have the sketch exactly as you want it.
- When it comes to sketching the trees next to the cottage and to the right of the out-building, you should indicate only roughly where the main trunk is positioned and where the branches start to emerge from the trunk. You do not need to put in every twig on the tree; you can add a lot of this detail with the paint brush later.
- Also get down the pencil lines for the road leading into the centre – the focal point – which then disappears around the corner to the left.
- When you have the main structure of the sketch finished, put in a few markings to give you an idea where the stones are going to be, especially around the little door in the out-building. This door is a real centre of interest, and the stones around it will make it stand out. Again, you needn't put in all the stonework detail with the pencil.
- Moving across to the left-hand side, indicate the foliage as it comes out from the hedge and falls down towards the path. Add this in a very loose form, making the pencil dance around on

the paper. It would look unnatural to put in hard, definite lines because the foliage has a coarse, haphazard edge to it. There are very few perfectly straight lines in nature.

• Do not sketch in the grass area: simply make a few marks on the paper to indicate where the shadows are on the path and grass.

• Once you have completed your sketch and you are happy with it, you will need to apply masking fluid to the trees. Start with the one on the right-hand side and be liberal with the applications. You can see that the sunlight is really hitting the tree, which stands out against the dark background, so you have to save the white of the paper for it. Apply the masking fluid to the trunk and branches with the No.5 brush, working for no more than 40 seconds at a time. Then go back into the water and clean off the brush thoroughly, squeezing the hairs between your fingers and thumb to remove all the latex. Getting the brush completely clean is something you will need to practise.

• Now apply masking fluid to the tree next to the cottage. You need it only on the trunk and branches against the dark background, not on those parts silhouetted against the sky.

STAGE 1

• Mix up the following washes for the sky:

RS with a tiny amount of AC in a very dilute mix
FU, AC and a lot of water
FU with a touch of LR

• You will need to keep the sky pale and fluid, but you will not need to add a lot of fuss and detail. Using the 19mm (¾in) brush, start by semi-wetting the paper in the area about half-way between the top and bottom of the sky. Use swirling strokes in circular movements, but be very careful to cut neatly around the roof of the cottage.

• When this is done, apply the first mix of RS and AC using the same swirling movements, angled towards the top of the clouds where the sun is catching them. Put this on quickly, and while it is drying, introduce the mixture of FU and AC without washing the brush. If you wash the brush, you will dilute the wash even further. The second wash goes on in a cradling motion, applied to the underside of the clouds. Do not be afraid to lift the brush off the paper occasionally: it does not have to be kept in permanent contact.

• Return to the mixture of RS and drag the brush across the

lowest area of the sky, blending it down into the foliage next to the cottage
and cutting neatly along the shapes of the wall, up the side of the roof and down the back of the roof.

● While this is still very wet, put on the mixture of FU and LR. Work it in and around the sky, starting at the top left-hand corner and coming in towards the centre. Avoid touching the wash of RS that is already drying; instead, move around it and leave a space. Bring this blue wash across the top of the paper, working from left to right, and pull it down from time to time into the mixture of FU and AC that has already been applied so that the washes merge and bleed together. The sky gets narrow across the top.

Now pull it down from the top of the left-hand side and in towards the centre to form a cloud shape just behind the tree.

● Dip the brush into the water, take it out and squeeze it between your fingers and thumb to remove excess wash. Wet it again slightly and blend between the colours, moving back and forth between the original washes and the blue wash so that they meld together. Skip a bit now and again to leave some white areas, but start controlling the wash, touching it in a feathery way. You will not need to scrub too much, just touch, blend and bleed it through until it does exactly what you want. The sky should be soft and all the colours equally diffused. Allow to dry.

STAGE 2

● When the sky is dry, block in the roof tile colour using the No.8 brush and a wash comprising:

FU with a touch of LR and some AC to create a purple shade

● Take the excess wash off the brush and touch the roof with the point to test the colour. If it is too dark, lighten the mix with water; if it is too light, darken the mixture with FU. Begin painting along the top of the roof and pull the brushstroke down in the direction of the fall. Allow to dry.

● Once the roof is dry, apply a mixture of:

RS and AC in a very dilute wash

with the No.8 brush to all the stonework and buildings. Start with the gable end wall, come down from the point and then move down the side edge of the wall. Do this in blocks. If you are quick enough, you can start at one side of the painting and work through and across to the other side, filling in as you go.

● If you want to do it this way, I suggest that you begin at the far end of the cottage and work up and down as you move forward. Apply the wash as if you might imagine the tide coming in across a beach. Remember to make up enough mixture before you start this process. If you think you're going to run out of the wash half-way through, you will end up with hard edges – something you definitely don't want. If you find yourself in such danger, you will have to look for a 'safe landing zone', namely a corner. This can be any pencil line denoting structure, such as a corner of a gable or the top of the wall of the out-building. In this picture, I suggest you go to the bottom left-hand corner of the gable end wall, along the top of the wall that is in shadow and stop before the out-building.

● All the buildings should be painted with:

RS and AC

This underpainting will shine through anything else you put on top. Subsequent washes will be secondary washes applied in a layering process to build up texture.

- Allow to dry and then block in the chimney.
- When the walls are dry, turn your attention to the foliage next to the cottage. This is going to be very diffused because it is in the distance and its true colour will not be visible.
- Mix up:

FU and LR in a mid-bodied wash

Apply this wash to the foliage with the side of the No.8 brush, holding it so that the hairs run parallel to the paper. Start at the top of the trees and drag the hairs in a downward motion to give a broken outline to the top of the foliage. Then continue to fill in the rest of the foliage, leaving the odd white space and the jagged edge in the foreground foliage next to the cottage. Paint neatly around the cottage outline where it meets the foliage. Thin out the wash as you approach the bottom of the trees.

- Mix up:

WY and WB with a touch of LR in a mid-bodied wash

to produce a mid-tone green. Brush this on, giving a rough, broken edge to the top of the foliage and come down the right-hand side of the tree. It will not matter at this stage if you paint over the tree because it is protected by masking fluid. Bring the wash down to meet the grass area at the bottom of the bank, then cut neatly around the walls of the cottage and the roof of the extension, making sure you show the overhang of the roof. Finally, bring the wash down the furthest wall to meet the grass.

- You can produce a deeper mixture of green by adding more WB and LR. Using a No.5 brush, feed this into the wash near the cottage because the densest darkness is at the furthest end where there is very little light. Encourage it to bleed into the drying wash by pushing the brush outward. The colour will explode into the drying wash to give a two-toned effect. Show darkness towards the bottom of this wash area by adding some of the second colour towards

the grassy patch and leave a broken edge along the bottom to show that some grass is growing up into this foliage.

- Now prepare a wash of:

FU and LR in a full-bodied mixture to create a dark purplish-blue shade

Brush this into the drying wash along the edge of the cottage, pushing out slightly to encourage it to bleed through. You should now have three different colours within the wash: a light green with a darker green bled into it, and the very dark purplish-blue colour merged into the light green towards the bottom of the wash along the grass bank and the side of the cottage. These colours should all blend together to give you a wash similar to that in the illustration.

- Mix up a wash for the grassy area in the foreground, using the 19mm (¾in) brush. You will need a lot of water to create a very dilute wash and a combination of:

WY and WB with a tiny amount of LR

which will produce a pale green tone.

- Start brushing this in from the area beside the right-hand tree. Brush it across in horizontal strokes from the wall to the edge of the roadway. Work quickly from right to left as you move towards the bottom of the painting. Create quite a strong line towards the edge of the road, but it should not be absolutely straight.
- While this wash is wet, continue working backwards, filling in all the grassy areas. As it dries, bleed in a wash of WY, WB and LR in a slightly darker green mixture to give some texture to the grass. Brush this in from right to left. To give texture to the foreground, do not cover all the light green.
- When this stage is completed, dilute the wash and roughly block in the foliage on the left-hand side. Work downwards to the road. While this is still wet, feed in some darker accents of green with a wash of:

WY, WB and LR in a mid-bodied mix

Use this to produce some of the rounded bushes towards the bottom of the foliage area.

STAGE 3

• Now you can start to work on the road. Mix up:

RS with a touch of AC in a very dilute mix

and apply with the 19mm (¾in) brush. Start at the furthest end of the road, pulling the brush towards you, first along one side of the road, then along the other. Do this until both sets of strokes meet in the centre of the road.

• If you leave any light or unpainted areas within the road, at least they will be going in the right direction and will add to the texture of the surface.

• Prepare a mid-bodied wash of:

FU with a little AC and LR

and pull this into the central area of the road with one stroke from the far end to the foreground; add another stroke from the back end to the right-hand, and another stroke from the back end to the left-hand.

• Squeeze the brush between your fingers and thumb to remove the excess wash from the hairs. Use the semi-dry brush to blend these washes into the drying wash with brushstrokes in the same direction. You will retain some of the texture on the road surface, but it will still look very smooth.

• Make:

RS with a touch of LR in a very dilute wash

and apply this secondary wash to the gable end wall of the cottage, using vertical and horizontal strokes of the No.8 brush. This will highlight the stone effects on the building. Repeat the process on the sunlit side of the out-buildings and add touches to the stonework. It will not do any harm to bleed in the same wash, but in a slightly stronger mixture, while this stone area is wet. It will give a diffused look to the stonework. In selected places, add a touch of WY to this wash to give a greening effect. Allow to dry.

• To create a stone-like effect on the secondary wash, prepare the following washes:

RS with LR in a mid-bodied wash

LR and FU with more LR in a mid-bodied wash

FU and LR with more FU in a mid-bodied wash

• With the No.8 and No.5 brushes put in some textured shapes for the stonework you indicated in the initial pencil sketch. Most of the stonework is on the out-building. Use the No.8 brush for large stones and the No.5 for small ones. Some stones will be slightly blue, some slightly yellow and others will veer towards brownish-red. Scatter them throughout the wall, but do not try to paint in every single stone: sporadic positioning creates a better effect. Allow to dry.

• To tackle the shadows, you will need to mix up a mid-bodied wash of FU with a touch of LR. It is very important to get this mix right before applying it to the painting. It needs to be strong, but not so strong that it dominates the picture and looks ridiculous.

• Practise to find the right shade, then start applying it with the No.8 brush to the far end of the roadway and the foliage next to the cottage. Start below the top of the bushes and show the shadow falling downwards and in flat strokes across the road. Follow the lines you sketched in earlier for the shadows.

• Use vertical strokes to put shadow on the front of the cottage and falling strokes on the roof. Cut neatly down the gable end corner of the building. Move along the wall that is adjacent to the cottage and in shadow and the gable end wall of the out-building. Continue across the road in a horizontal brushstroke. Put in the rest of the shadows on the out-building walls and on the grass verge. Note the shadow cast by the coping-stones on the out-building and the overhang of the slates on the gable end of the cottage. Use upright strokes on upright surfaces and horizontal strokes for the grass.

• Let this all dry before you paint in some of the branch shadows on the wall. Thick branches should be put on with the No.5 brush, and thinner ones with the No.2 brush. Do not try to put in a shadow for every single branch you see,

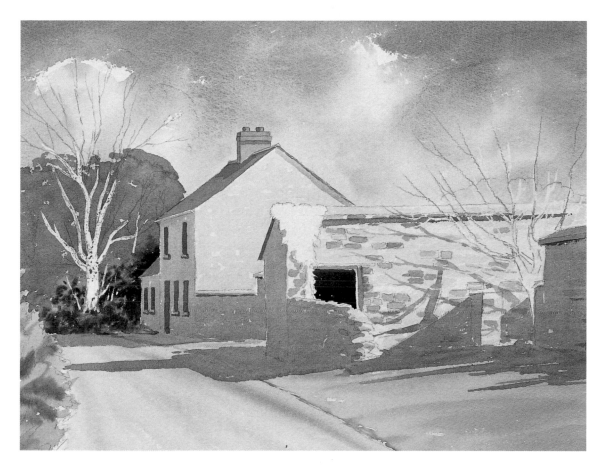

just a few to indicate that the sunlight is shining through the tree and making shadows on the wall.

● Put in a shadow on the left-hand side of the chimney and underneath the jutting brickwork at the top of it. There are also shadows cast by the overhang of the roof on the gable wall. You will notice that whenever this bluish wash goes over the stonework, it takes on the stone colour underneath, yet still gives that perfect shadowy look. When it goes over the grass areas, it gives a green shadowy look. You will see immediately that with the introduction of shadows, the

painting is given real impact. Three-dimensional buildings really bring it to life. Allow to dry.

● Now paint in the dark doorway with a mixture of FU and LR in a full-bodied mix. The stone edges of the doorway will be coarse and jagged rather than straight.

● When this is dry, thin down the wash slightly using the No.2 brush and paint in a few joints between stones on the wall of the out-building. Now you will be able to see just how important shadows are in a painting.

● Brush in the windows at the front of the cottage.

TIP

• Shadow colour must be put on very quickly so that no part of the wash dries while it is being applied. It should be brushed on like the tide coming in, bringing the wash gradually in towards you.

MASKING FLUID IS INVALUABLE FOR KEEPING OBJECTS, SUCH AS TREE TRUNKS AND BRANCHES, FREE OF COLOUR UNTIL YOU'RE READY TO PAINT AND IT'S EASY TO USE. REMEMBER TO WASH YOUR BRUSH EVERY 40 SECONDS TO PROTECT THE HAIRS. SIMPLY REMOVE THE MASKING FLUID WITH A CLEAN PUTTY RUBBER OR WITH YOUR FINGERS.

STAGE 4

● For the final stage all you have to do is paint in the trees and add finishing detail. First, though, making sure the painting is completely dry, remove the masking fluid you put on earlier. It can be removed with a clean putty rubber or with your fingers, whichever method suits you best. Work from the lowest point of the tree and rub upwards. The masking fluid will peel off easily, leaving the white paper beneath.

● Using plenty of water, mix up a wash of:

RS and BS with a tiny amount of FU to produce a pale brown wash in a very dilute state

The wash needs to be in this dilute state because there are many light branches in the tree.

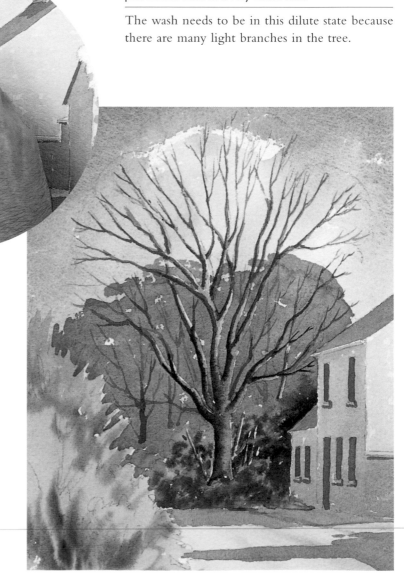

• Apply the wash to the tree with the No.8 brush, moving upwards and letting the brush taper as it goes towards the top. As the branches become thinner, switch to the No.2 brush to complete the tree.

• Darken the wash slightly by adding a mix of BS and FU. Pull the brush up along the branches, flicking up towards the tapered point at the end. Try to follow the branches in the direction that they would grow from the trunk.

• You will now need to prepare an even darker mix, which should be produced with:

NT and BS in a mid-bodied state

Use the No.8 brush to start with, and apply this wash to the bottom part of the tree on the left-hand side, and to any subsequent branches on the left. Change to the No.2 brush to work on the thinner branches. About half-way up the tree, lighten your wash slightly to paint the thinner branches that are not very strong against the light sky. Do not apply this secondary wash to any parts of the trunk that are very pale and sunlit: just emphasize the darker side and the darker branches in the tree. Treat the tree on the right-hand side in the same way.

TIP
• **Do not use straight edges on the stones. They are never perfectly square.**

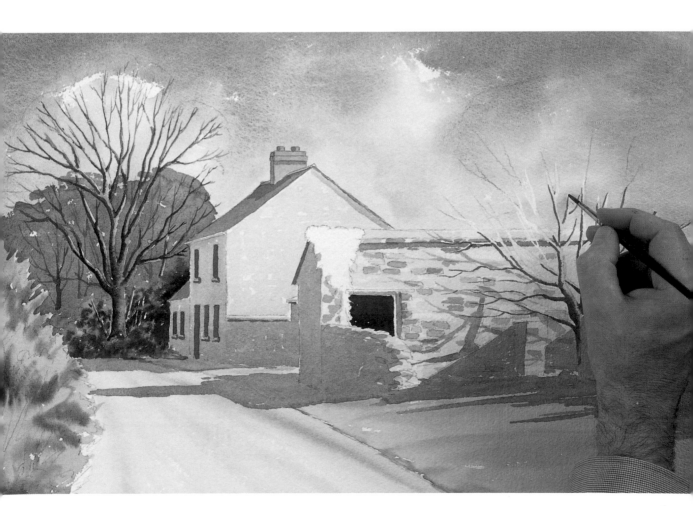

● Once this is completed, add the ivy above the doorway of the out-building using the No.8 brush with a very pale green made of:

WY, WB and a touch of LR

Use the same three colours to mix up a mid-tone green and bleed it into the first drying wash. Paint in all the bits of greenery and shrubbery.

● Now you can start to put some figuring on to the foliage on the left-hand side. This is done with flicks of the No.5 brush and a mixture of WY, WB and LR. This wash should be darker and thicker than the previous wash. Flicks should veer to the right and left as well as straight up, and should be kept short and tapered.

● Whenever you think the painting looks as if it contains enough detail, it is complete.

TIPS
- **Do not overwork the painting. As soon as you feel you have enough detail, let it go.**
- **Refer back to previous exercises in the book to help you achieve the effects you are looking for.**
- **Remember to use a piece of test paper to check the colours of washes.**

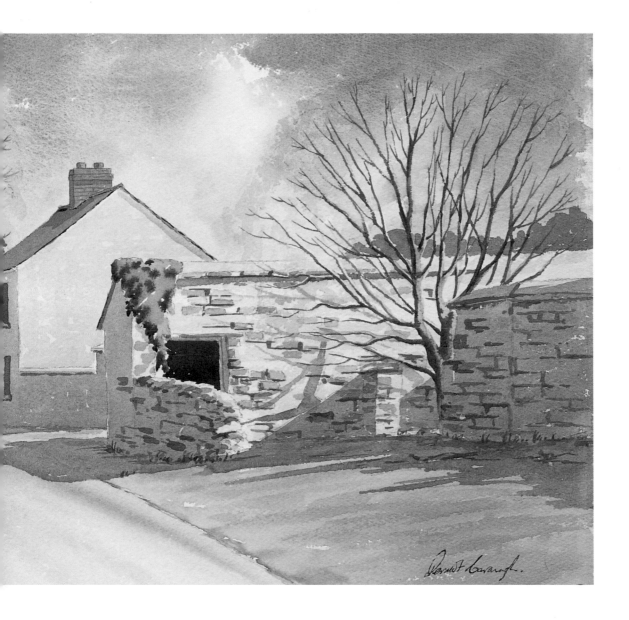

I've always had an interest in art. I have dabbled slightly, but up until now I've really only been messing about… The building has a lovely old feeling. It's very interesting.

THE WATER GARDEN IN THE GROUNDS OF TEMPO MANOR

This striking water garden in the grounds of Tempo Manor is in County Fermanagh. There is a whole variety of different coloured foliage on display, reflections of all kinds, a charming little boat in the foreground, small beds of lilies floating on the water and a large and beautifully formed yew tree that captures the imagination.

With a garden location like this, it was inevitable that *Awash with Colour* should enjoy the company of a celebrity who spends most of her time in the garden. Charlie Dimmock, invaluable member of BBC TV's *Ground Force* and star of her own series, *Charlie's Garden Army*, was a vivacious and humorous guest on the show. You can see why she has endeared herself to millions of viewers. She rarely stopped giggling from the moment she started painting, and she brought a ray of sunshine to the show. We're still recovering.

Although Charlie Dimmock is familiar with drawing and sketching through her work of designing garden features, she was really taken with watercolour painting, and was fascinated with colour mixing, an important element in garden design. The colours, she admits, will give a new dimension to her drawings.

Materials

640gsm (300lb) watercolour paper with a rough surface in half-imperial size
HB pencil
Masking fluid
Putty rubber
19mm (¾in) Flat Sceptre Gold brush
No.8 Round Sceptre Gold brush
No.5 Cirrus Sable brush
No.2 Cirrus Rigger brush

- To create a sense of space in the painting you will have to throw the distant bank of trees back slightly by blueing them. We'll come to this.
- First to the pencil sketch. Mark the background waterline on the lake slightly below the half-way line of the painting. This is a horizontal line and always remember that the water will lie flat.
- Now you can work forward among the middle-distance foliage and shrubs, and sweep around the water's edge down to the bottom left-hand corner of the lake.
- Whenever sketching something like this, draw in the general shapes of each 'block' of varying colour within the mass of greenery, so that you know where each starts and stops when painting.
- Once the sketch is finished, apply masking fluid to the right-hand sides of the yew trunks, which appear light against a dark background. For the same reason, add masking fluid to the lilies, which are pale against dark water, and to a few areas of shrubbery in the background, where there are many light, colourful flowers.

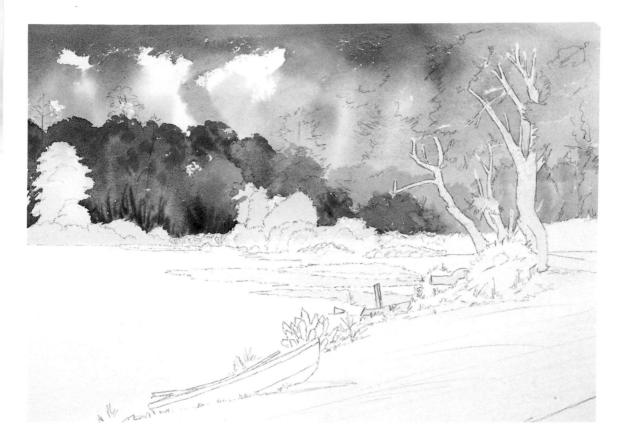

STAGE 1

• When you are happy with the sketch, you can tackle the sky using the 19mm (¾in) brush. To do this, mix up the following washes:

RS with plenty of water
FU, LR and a touch of AC in a mid-bodied mix
FU with a touch of LR to take the edge off the blue

• You will not need to have a fussy sky because there is a lot of detail in the foreground. The two areas should not be competing for attention.

• Before you start applying the washes, dampen the sky area using swirling brushstrokes. Then introduce the mix of RS and water, working up and around the sky area in a fluid motion to create clouds.

• Into the underside of this first wash, bleed the mixture of FU, LR and AC to produce warmth within the clouds and add cloud shadows.

• Finally, apply the bluer wash of FU and LR. Start from the top left-hand corner and work down towards the centre. Move the brush across the middle of the paper, then pull in from the top right-hand corner towards the centre once more and blend all the colours together very lightly.

• Do not worry about painting over the trees in the background. They are going to be darker than the sky, which can fade out towards the lake. Bring down the sky and lighten it with water in a graduated wash as it recedes down and towards the water-line. Allow the sky to dry and the colours to merge.

• Now you can paint the trees in the far distance. To do this, use the No.8 brush turned on its side and apply a wash of FU and LR. Paint in the tops of the tree shapes first and then

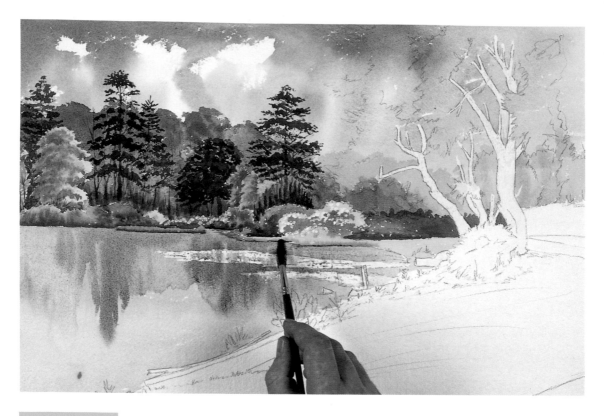

STAGE 3

- For the water and reflections, mix up a wash of:

FU and CB with a touch of LR in a mid-bodied mixture

- Apply the wash with the 19mm (¾in) brush and pull it across horizontally from left to right, just as you would a graduated wash. Start with the denser blue at the far side of the water, and as you come down towards the front, introduce more water to the mix to dilute it. In this way, the wash will graduate and become lighter. This should be applied quickly to avoid runs in the wash. Try to keep the bubble along the leading edge (your last brushstrokes) of the wash, but do not let it become too full. If this happens and the bubble overloads, wipe away the excess with the brush. Pull this wash forward and keep it very wet.
- While it is still wet, you can move on to the reflections. Mix up some:

WY and WB with a small amount of LR to make a light green

and use the No.8 brush to feed it into the drying wash that has already been applied. Use vertical strokes, pulling down from the water-line at the back of the lake. As you pull down, try to mirror the shapes of the trees above. Tall trees need tall reflections in the water, just as small trees need small reflections. Copy what you see and remember to work quickly.
- When you have completed this wash, and while it is still wet, feed in the next mix. This is another variation of:

WY, WB and LR in a thicker, mid-tone green

which should be merged in using vertical strokes. It must not cover all the light green area you have applied. Put it on in such a way as to show a variation in the tone of the reflections.
- To mirror the reflections of the dark conifer trees and the shadows in the shapes above, brush in another wash of:

FU, WB and LR in a darker mixture

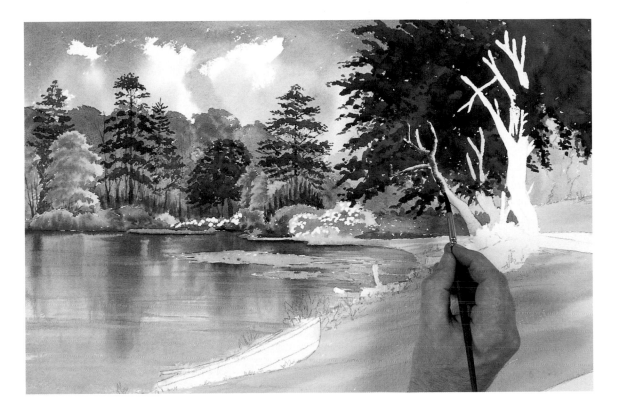

and apply it to the lake. Where there is a dark tree above, put a dark reflection into the water. Take care not to flood the wash with this dark mixture because it will take over, to the detriment of all the other reflections.

STAGE 4

• The leaves and foliage of the large yew tree in the foreground are painted with the No.8 brush and:

WY, WB and LR in a mid-bodied wash

This should be quite a thick mix and contain a lot of WB. To give variation in tone, introduce more LR into the centre of the foliage, but do so in a very loose and fluid way, leaving lots of holes in the foliage itself.

• If you are working around the edges of the leaves, use the point of the No.8 brush to give a broken outline.

• When bleeding in a darker wash towards the centre of the foliage, where there is lots of shadow, introduce more LR and WB to the area. You should mix this wash slightly thicker because it will bleed better than the wash you have already applied.

• Paint the foreground using the 19mm (¾in) brush with a mixture of:

WY, WB and a small amount of LR

and follow the slope of the ground. Bring the brush from right to left, sweeping down towards the water's edge, and leave the side of the lake jagged so that you can have grass and shrubs growing there.

- Combine:

WY and FU with a touch of LR in a dark, mid-bodied mixture

and feed into the drying wash to show texture within the grassy expanse. This is similar to exercises featured earlier in the book (see end of Exercise 8 on page 51 or beginning of Country Pathway on page 54). Allow to dry.

- When this is dry, remove the masking fluid from all the areas you covered at the beginning. Use a clean putty rubber or your fingers and work upwards. If the washes are not completely dry, they will smudge.

- Paint the area containing the lilies with a mixture of:

AC and LR in a dilute mixture

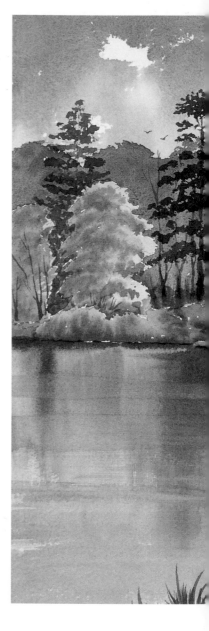

Leave some natural white areas on the paper to represent the lilies within the pond.

- For the trunk of the yew tree, use a mix of:

RS with a tiny amount of NT

This should be a very pale and dilute wash, applied with the No.8 brush. Just before it is dry, feed:

BS and NT in a mid-bodied mix

into the side facing away from the source of light. This should spread about a third of the way across the original wash, creating the shadowed side of the trunk and a sense of roundness.

- Add the finishing touches by painting in the boat. You can also brush in some coloured flowers in the shrub areas originally covered by the masking fluid. Use an array of purples, pinks, yellows, blues and reds to bring brightness to the foreground – go on, enjoy yourself mixing colours.

❝ I did sketches at school, mostly still life. I'm not good with landscapes. Things plonked in front of me I can just about cope with. I used to get told off for not using enough colour. ❞

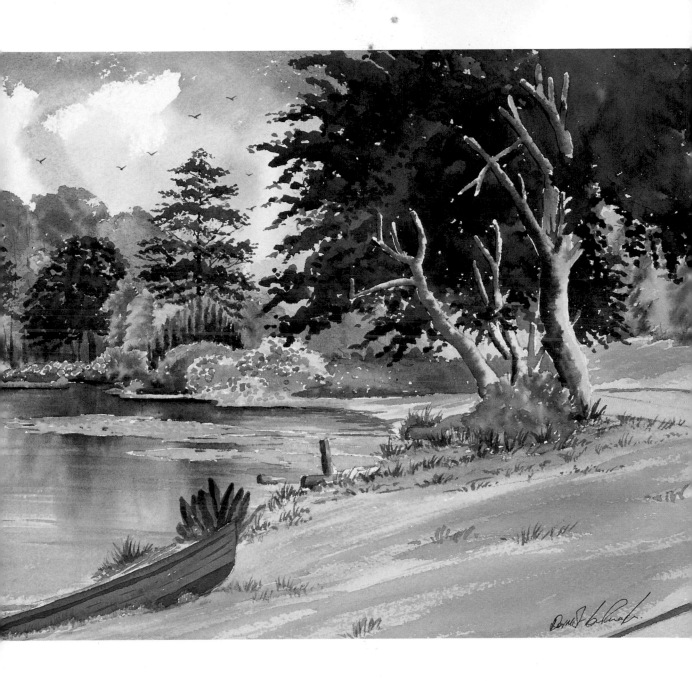

CHAPTER 6

Gallery

The pictures in this chapter were all painted during the second series of *Awash with Colour*, as we journeyed along Ireland's beautiful tourist trail, the north-west passage from Dublin to Donegal.

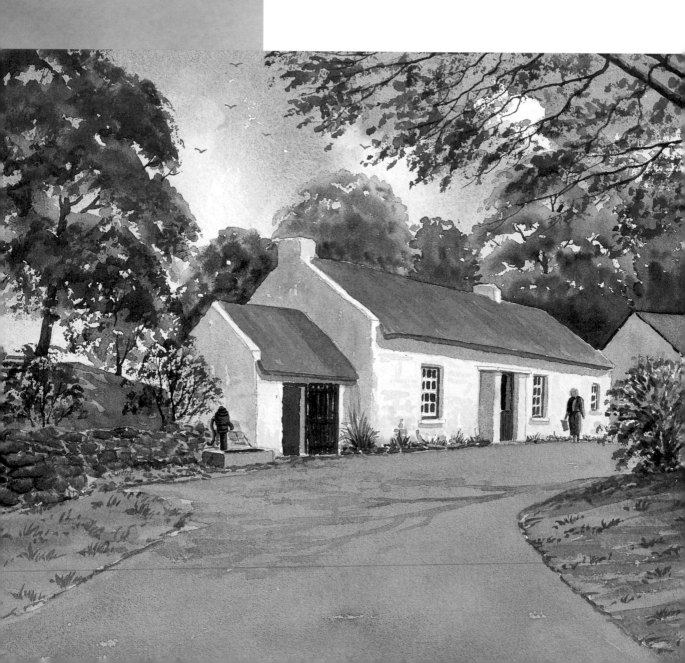

1 Weaver's Cottage at the Ulster American Folk Park

The Ulster American Folk Park near Omagh in County Tyrone is a living museum, where they have reclaimed and rebuilt a lot of the old houses that used to be common throughout the Ulster countryside.

The park addresses the issue of emigration from the early eighteenth century onwards and conveys something of the existence of the people who left. The Old World section of the grounds reproduces the daily lives of Ulster folk, while the New World section re-creates the dwellings and conditions the people encountered when they arrived in the USA.

Although the subject is called the Weaver's Cottage, it is also known as the Mellon Homestead. It belonged to the Mellon family, one of whose members, Thomas Mellon, settled in Pennsylvania and went on to become a judge, banker and millionaire.

The guest on *Awash with Colour* when we visited the Ulster American Folk Park was Cathy Stevens, who was the American Consul General in Belfast at the time.

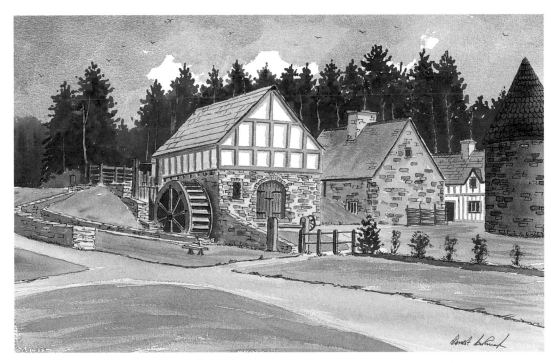

2 Ulster History Park

The Ulster History Park is another impressive theme park in County Tyrone, which depicts the story of man in Ireland during a timespan from 8000 BC to the mid-seventeenth century.

The park is devoted largely to reconstructions of buildings from Mesolithic to medieval times, by way of the Stone, Bronze and Iron Ages, the Vikings and the Normans. Among its fabulous buildings are those featured in this painting.

Irish television researcher Clarissa Neil was the guest painter for this programme.

3 Armagh city skyline

Armagh is a city that boasts some of the finest Georgian architecture still in existence. It is also the ecclesiastical capital of Ireland, famous for its cathedrals and spires. St Patrick built his first church here in the fifth century. Today the city is proud of its two cathedrals, both named after the patron saint: St Patrick's Catholic Cathedral and St Patrick's Church of Ireland Cathedral. They stand on adjoining hills.

The painting guest was the Reverend Robin Eames, Archbishop of Armagh and Primate of All Ireland. It was a delight helping him to paint the city to which he has contributed so much and helped to revitalize.

4 St Stephen's Green

Standing in the centre of Dublin, St Stephen's Green is one of the most picturesque parks in Ireland. It is an oasis of greenery within a thriving city. It boasts boating lakes, woodland and formal gardens of different kinds, providing a peaceful haven far away from the madding crowd.

Valerie Waters, the horticulturist and television presenter, joined me on the programme when *Awash with Colour* visited Dublin. I think this picture conveys the serenity of the park away from the hustle and bustle of city life.

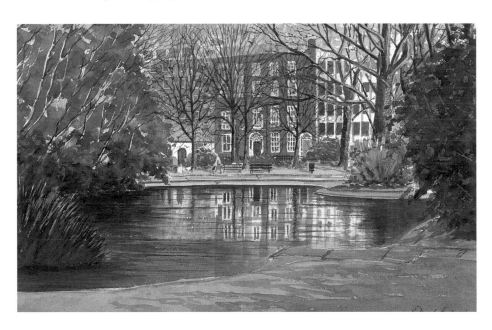

5 Butterstream Garden

Trim in County Meath is the site of Butterstream Garden. It was founded several years ago by Jim Reynolds, an archaeologist by profession, who has a consuming passion for horticulture and a love affair with gardens.

The founder himself was the programme's guest, swapping his archaeologist's trowel for a paint brush to paint his own garden on television.

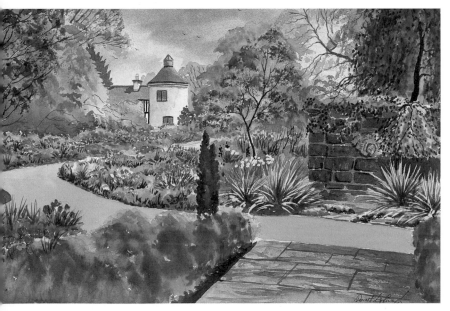

6 Slieve Gullion Mountain

Slieve Gullion, meaning the mountain of Cú Chullain (a legendary Irish hero) is in South Armagh, near the town of Forkhill. The subject of our painting was an old broom-maker's cottage set in the woods about 274m (900ft) above sea level.

Our guest on the programme was Padraigin Ni Uallachain, the Irish Shannonois singer, who has performed her very distinctive style of a cappella singing all over the world.

This was one of my favourite painting locations. From the top of the mountain you can see many of the counties of Ireland.

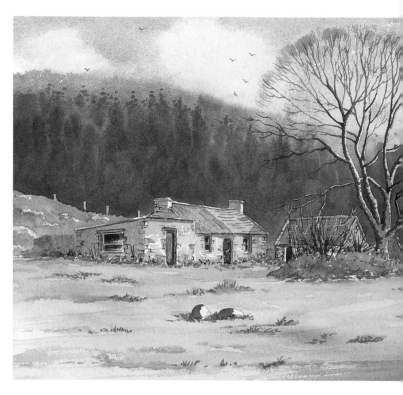

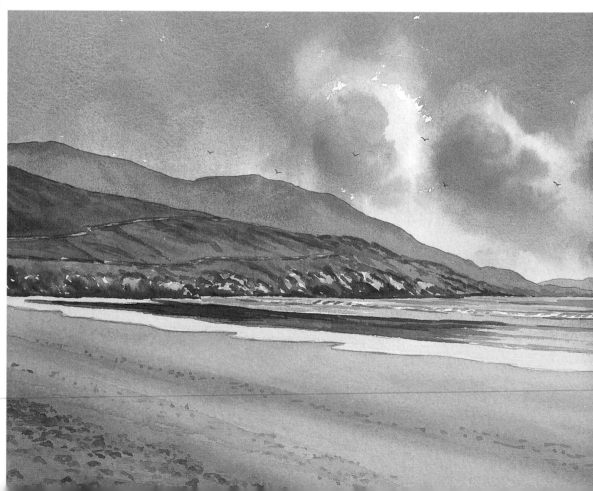

8 Dunfanaghy

Suzanne Dando, who was the special painting guest throughout the entire first series of *Awash with Colour*, joined us once again for the final show in the second series to paint this charming scene.

Dunfanaghy is situated on the north coast of Donegal, and we painted the picture looking back from Horn Head towards Dunfanaghy town. The children splashing about in wellington boots are my two eldest daughters, Mairead and Laura.

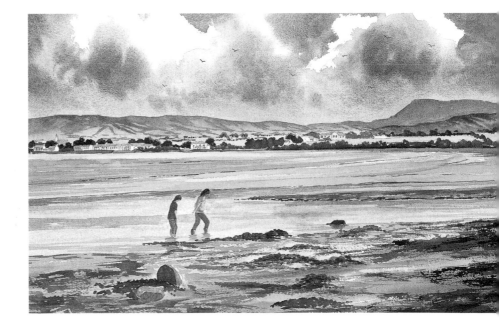

7 Lenen Strand

A peaceful beach scene at the Innishowen Peninsula in County Donegal. Although this is a very simple painting, it is nonetheless very effective.

The painting guest for the day was Gerry Anderson, the BBC TV presenter of *Anderson on the Box*, who also hosts his own morning radio show.

Gerry really enjoyed painting this picture, but he confided during our filming that this would be the show's first disaster because one of his schoolteachers had told him that he was so bad he was special.

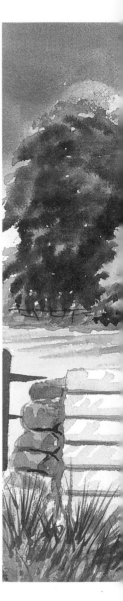

9 The bridge at Favour Royal

This delightful stone bridge is situated at Favour Royal Forest Park in the Clogher Valley, County Tyrone, and was once part of the nearby estate of Augher Castle.

The guest on the show was Suzanne Finlay, who, along with her rally driver husband, Stephen, currently occupies the castle. Suzanne is a former international rally driver herself, although today she is very much involved with the Irish show-jumping scene. She also breeds horses for equestrian events.

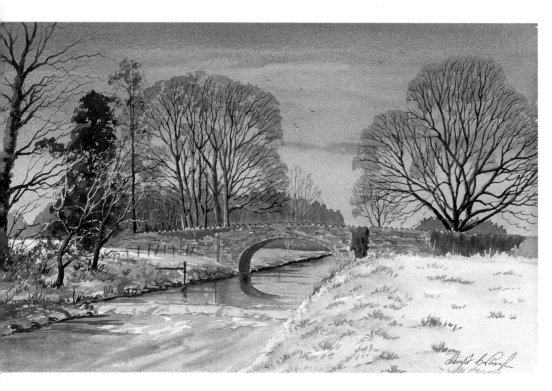

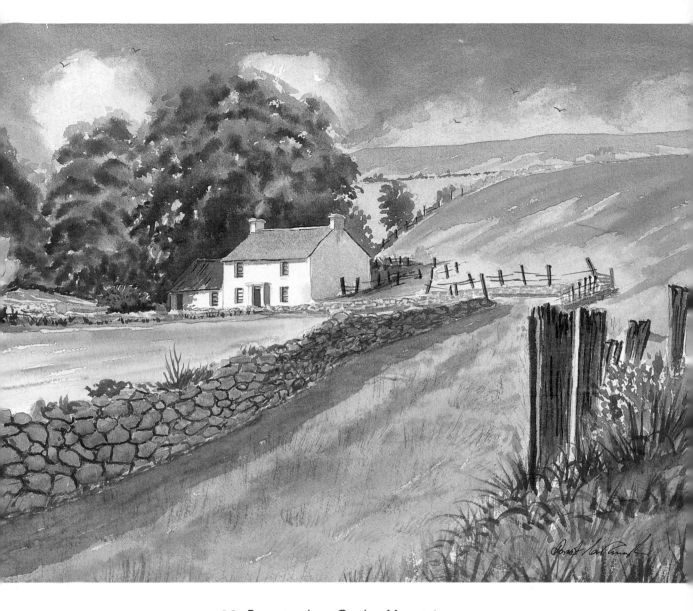

10 Farmstead on Cooley Mountains

This very attractive farmstead is in the heart of the Cooley Mountains near the town of Carlingford in County Louth. It is surrounded by stunning countryside that simply takes the breath away.

Kieran Goss, the Irish singer and songwriter, was the guest whose task it was to capture such beauty in watercolour.

Dermot Cavanagh took up the brush and palette at a very early age. A self-taught artist with a charismatic approach, he possesses a natural ability to pass on his painting techniques to others. He has presented four series of *Awash with Colour*, in which he teaches a different celebrity to paint in each programme. He demonstrates his talent to art clubs all over the UK and runs courses, workshops and painting holidays in the UK, Ireland and Europe. For more information contact Rhoneview Studios, 30 Seyloran Lane, Moy, County Tyrone, BT71 7EH, Northern Ireland, telephone 028 8778 4166, fax 028 8778 4184 or visit www.dermotcavanagh.com.

Howard Elson, co-writer, is a successful author. He has ghosted celebrity autobiographies and written biographies of Paul McCartney, Barry Manilow and James Last, in addition to a number of music and show business works and several children's books.